Paul
Cézanne
PAINTING PEOPLE

WITH AN ESSAY BY
MARY TOMPKINS LEWIS

NATIONAL PORTRAIT GALLERY, LONDON

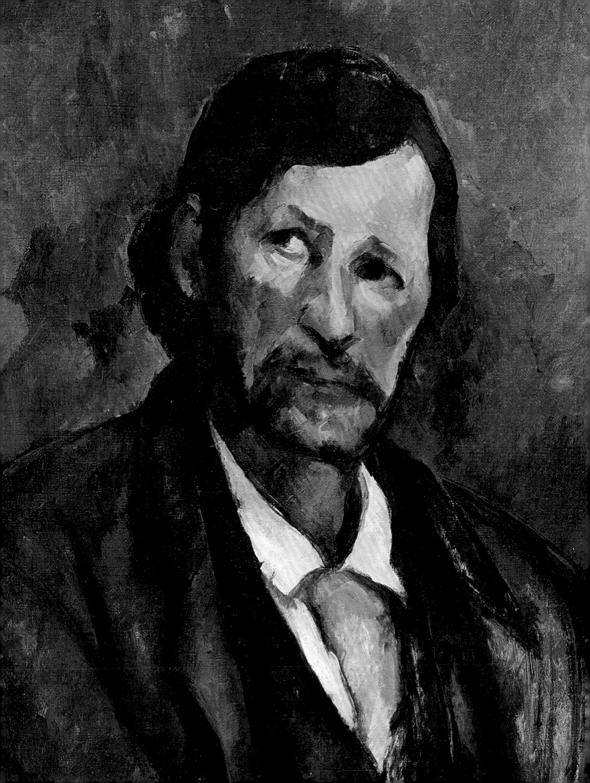

Contents

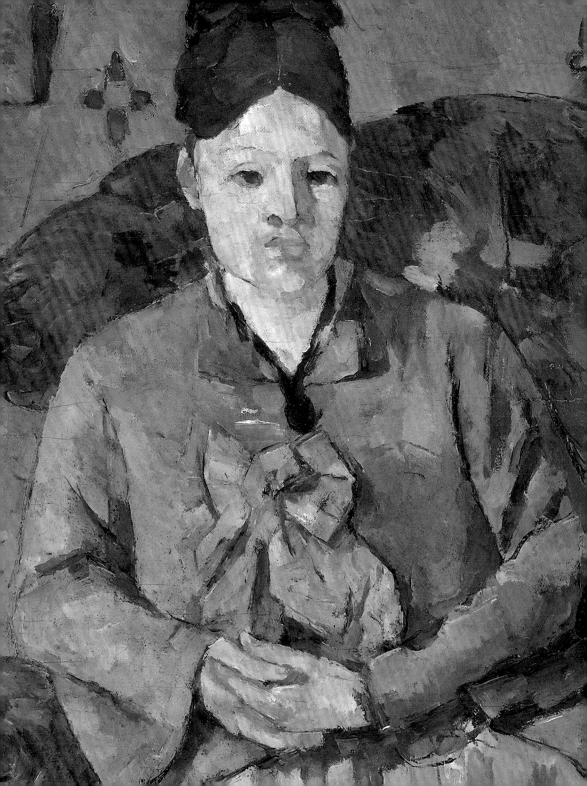

Faces, Figures and the Physicality of Paint: Cézanne's Portraits

MARY TOMPKINS LEWIS

IF PAUL CÉZANNE'S still lifes capture the rigorous order and control the solitary painter sought in his studio, and his landscapes the artist's love of his native Aix-en-Provence, what do his paintings of people summon for the modern viewer? Unlike most of his avant-garde peers, Cézanne never received a portrait commission, and many of his painted likenesses of friends and family members offer little information in the way of his sitters' individual personas, stature, or relationship with the artist. Even in the age of Impressionism, when the popularity of the inexpensive, photographic portrait encouraged painters to adopt more informal and expressive means in their portraits or to reveal penetrating insights into their subjects, the Provençal artist defied expectations. He may not have explored portraiture's revelations of others, but these works tell us a great deal about him. More than his landscapes and still lifes, Cézanne's portraits serve as markers or milestones in his long and prolific career, allowing us to ponder his perception and manipulation of the creative process and the genre. Cézanne's portraits not only invite us into the world he knew; they also allow us to contemplate the artist at work.

The Paris of the early 1860s saw an exponential growth of portraits at the annual state-sponsored Salons, where a particularly insipid brand of the genre, which the art critic Théodore Duret would deem 'the triumph of bourgeois art',[1] proliferated. Cézanne spent extended periods during that decade in the

FIG. 1

Uncle Dominique as a Monk,
1866–7

French capital and had to have seen them. And we can gauge his reaction from the first cohesive and compelling body of work in his oeuvre: a series of portraits of *c.*1866 that openly flout the pomp and polished artifice of Salon painting. These include both portrait busts and costume pieces painted in Aix for which his maternal uncle, Dominique Aubert, dutifully posed. Impressed by the rugged, palette-knife landscapes of another renegade provincial artist, Gustave Courbet, Cézanne adopted the brash technique in a series of likenesses that are built up of broad tonal slabs of paint and reveal above all his unmediated response to the physical facts of his medium. In such paintings as *Uncle Dominique as a Lawyer* (1866–7, p.28), Cézanne's coarse swathes of pigment render his subject's

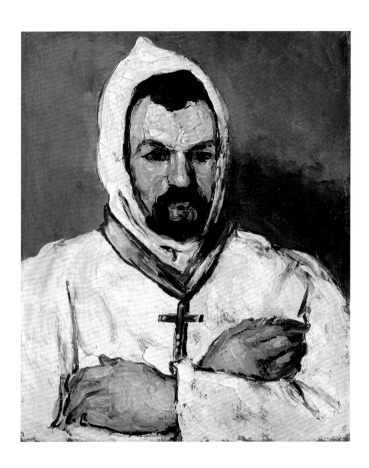

frozen stare and traditional jurist pose emphatically. They may also bear witness to his own intransigent status as an artist. Some years before, to the dismay of his affluent father, Cézanne had abandoned the study of law to become a painter; the crude bluster behind the portrait may reflect his own defiant choice of a vocation. A related painting of Aubert in the robes of a Dominican monk (1866–7, fig.1), while a likely play on his uncle's given name, is an even more defiant demonstration of the artist's wilful, rough-hewn technique applied dispassionately to his subject's image. The costumed figure's physically confining pose – in which the horizontal of his crossed arms is bisected by the cuff of his sleeve, the upright axis of the pendant cross and the vertical line of his features above – creates a taut pictorial structure. It barely constrains the mute subject's massive form and tactile presence on the canvas's dense, paint-laden surface.

In *The Artist's Father, Reading L'Evénement* (1866, p.26), which exhibits both a palette-knife technique and, below, a more fluid and measured touch, the artist seems to take stock of his early history as this heroic period draws to a close. Far less stormy a paternal likeness than one he had painted earlier on the walls of his family home, Louis-Auguste is shown sitting in a flowered armchair 'with the air of a pope on his throne', in the words of the artist's friend Antoine Guillemet. He is reading the radical, short-lived newspaper on which Cézanne's childhood companion Emile Zola briefly served as art critic (the elder Cézanne subscribed to the far more conservative *Le Siècle*).[2] As he had yet to secure the critical approval of his oldest friend or the blessings of his formidable father, Cézanne's still life that figures in the background (1865–6, fig.2) – painted in the audacious style that had consumed him for months – renders the portrait a manifesto of his potent beginnings and future aspirations. Although many of the locals scoffed, painting with a knife became all the rage for the artist's small band of *Aixois* admirers.

FIG. 2
Still Life with Sugar Bowl, Pears and Blue Cup, 1865–6

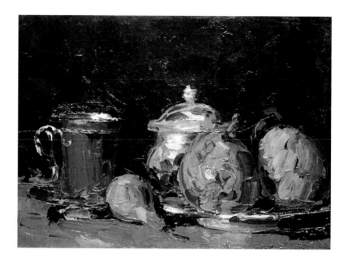

As his first decade of painting ended, Cézanne continued to forge his dreams of success through portraits of his intimates, but met with crushing defeat. A massive, melancholic image of the older Provençal painter Achille Emperaire, a tragic figure Cézanne captured with extraordinary sympathy, would be rejected by the Salon jury of 1870 and brutally caricatured in the press. After the political tumult that accompanied the Franco-Prussian War of 1870–1, Cézanne moved to the rural Ile-de-France to discover, under the tutelage of the artist Camille Pissarro (whose likeness he sketched in eloquent portrait drawings), the painting *en plein air* that would come to be known as Impressionism. Landscape would soon supplant figure and portrait painting in Cézanne's art, and his *Self-Portrait* of *c.*1875 (p.33) marked this dramatic change of direction. Posed with a piercing gaze before a landscape, painted by his fellow artist Armand Guillaumin (1871, fig.3) and depicted as seen in a mirror, Cézanne celebrates here, with vehement strokes and a theatrical flair, the intensity of his artistic vision and newfound focus, and the camaraderie he now enjoyed with vanguard painters in Paris.

Pissarro immortalised Cézanne's new stature in an affecting portrait of the artist in the rough, country garb of a rural landscapist (1874, fig.4). The older artist encouraged his new protégé to take part in the independent (or Impressionist) exhibitions he was co-organising as alternatives to the officially sanctioned Salons. Although Cézanne would show mostly still lifes and landscapes, his submission in 1877 of a portrait of Victor Chocquet (1876–7, fig.5) underscored the painter's burgeoning confidence. Chocquet was a minor government official, ardent admirer of the painter Eugène Delacroix and Cézanne's first real patron. He vigorously defended Cézanne's paintings on view at the Impressionist exhibitions, where they were mocked by unforgiving critics and viewers, and Cézanne's brooding and powerfully compressed portrait, arguably his

FIG. 3
Armand Guillaumin, **View of the Seine, Paris**, 1871

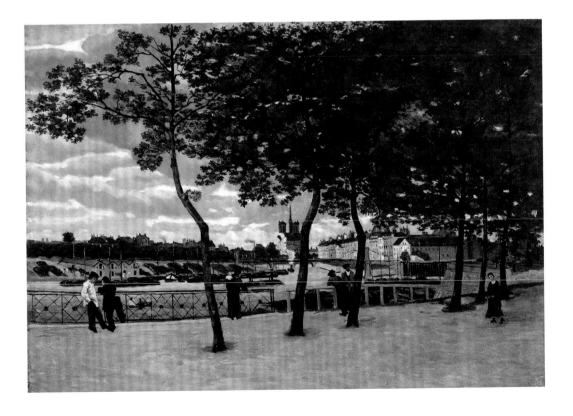

most radical to date, pays tribute to his faithful friend's support and cutting-edge tastes. Indeed, Chocquet became a kind of bellwether, sitting for some of Cézanne's most accomplished figure paintings of the decade, in which the painter gradually distanced himself from the Impressionist technique. His contemporary and fellow artist Edgar Degas, who was esteemed for his own percipient portraits, purchased a half-length canvas depicting Chocquet from this period, and attempted to acquire the most finished of the lot, Cézanne's portrait of Chocquet

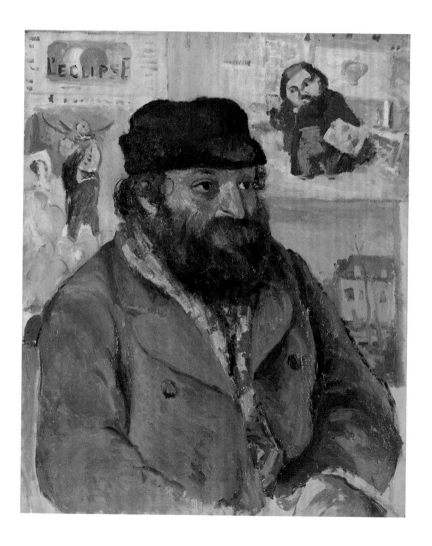

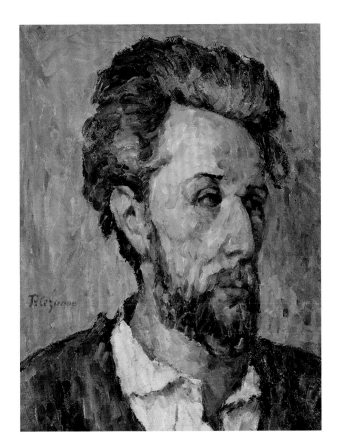

FIG. 5
Portrait of Victor Chocquet, 1876–7

seated (p.34) of 1877.[3] Built up of ribbons of patterned colour that glow like inlaid gems, the subject, shown perched on a chair in a decorous pose amid the gilt-framed paintings he owned, epitomises the image of a genteel, worldly collector, while his elegant surroundings evoke the new status Cézanne sought for his art.

The artist rounded out his second decade of painting with works that highlighted his distinctive vision and place within the ranks of the Impressionists. At the urging of his compatriots Claude Monet and Pierre-Auguste Renoir, he sought validation for the movement from his old friend Zola, whose fame now

FIG. 6
Château at Medan, *c.*1880

eclipsed them all. But it was not to be. Zola's pointed critique of the Impressionists appeared in the periodical *Voltaire* in June 1880. He attacked the group for lacking a scientific or formal rationale for their art and for failing to anoint an acknowledged leader. Cézanne responded swiftly in paint. His landscape depicting Zola's château at Medan (*c.*1880, fig.6), which was begun that same summer, offered a sweeping departure from the ephemeral, sketch-like views of nature that Zola had faulted in Impressionist painting. His old friend's dismissal of Impressionism seemed to bring to the surface something latent: at once a bold, systematic technique – using ordered, parallel strokes – and a disciplined, logical approach to composition. And once again, a portrait, in this case the *Self-Portrait* of 1880–1 (p.40), is a bold harbinger of the painting.

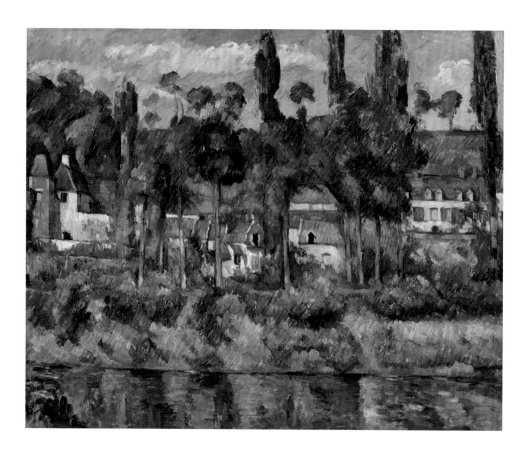

Apart from his achievements and artistic standing, the painter's domestic life became richer in the 1870s, and this too can be gleaned from his portraits. Hortense Fiquet, Cézanne's model, mistress and, eventually, wife (and mother to their only offspring, Paul *fils*, b.1872), appears in a number of sketchbook drawings from that decade, and in paintings as well. The artist would produce almost thirty portraits of her over the course of his career, and in these strikingly dissimilar and often impenetrable likenesses of his overtly familiar subject – who rarely resembles herself from one canvas to the next and never seems to age – Cézanne would fundamentally transform the pictorial potential and vocabulary of portraiture in his art.[4]

Such paintings as his magisterial *Madame Cézanne in a Red Armchair* of *c*.1877 (p.39) have become almost inseparable from the praise heaped on them by Cézanne's earliest devotees, the subject eclipsed by reverent analyses. The young poet Rainer Maria Rilke first saw the portrait at the 1907 Salon d'Automne commemorative exhibition. In a rapturous letter to his wife, he praised the painting's delicate harmonies and superb colour relationships, in which it seemed 'each spot had a knowledge of every other'. While the canvas's colossal chair ('the first and most quintessential red armchair in all of painting', according to Rilke) would become a fixture in subsequent avant-garde art, the poet's exquisite descriptions of the portrait's formal characteristics set aside the abiding question of its verisimilitude and laid out the painting's compelling appeal for early twentieth-century painters.[5] Cézanne's elemental modelling of Hortense's mask-like face in discrete patches of colour would resonate, for example, in the early portraits of Henri Matisse (who acquired two other versions of the subject, including a delicate and almost transparent canvas of 1885–6; p.47). A related – and equally opaque – painting, *Madame Cézanne with a Fan* (*c*.1879, fig.7), is referenced in the work of Pablo Picasso. It hung in the Parisian salon of the American writer Gertrude Stein, and haunted the Spanish painter as he struggled to capture Stein's

FIG. 7
Madame Cézanne with a Fan, c.1879,
reworked 1886–8

likeness, in the end replacing her visage with a virtual mask –
unthinkable without Cézanne's painting as precedent.

Rilke's brilliantly perceptive response to *Madame Cézanne
in a Red Armchair* makes regrettable how little he said about
other works on view in 1907, such as the artist's *Madame
Cézanne in a Red Dress* of 1888–90 (p.52). A far more complex
portrait of Hortense, marked by the sitter's strangely bifurcated
face and figure, and precarious pose in an unstable setting, the
canvas was treated to an extended exposition by the British
painter and formalist critic Roger Fry. Although indifferent

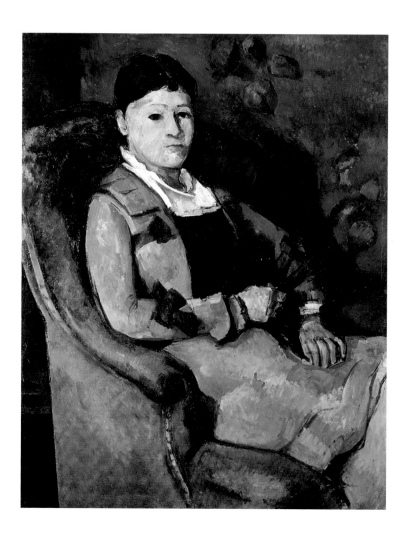

to its subject, Fry was moved by the painting's pictorial harmonies and transcendent beauty, observing: 'It belongs to a world of spiritual values incommensurate but parallel with the actual world.'[6]

Unlike the paintings of Hortense, which continue to enthral and perplex scholars and viewers alike, Cézanne's numerous sketched and painted likenesses of his son have received scant critical attention, serving chiefly as foils to the paintings of Madame Cézanne because they engage us in crucially different ways. To a remarkable degree, in fact, they function like traditional portraits. They resemble each other and Paul *fils* himself, as seen in surviving photographs; they coherently map his early years from infancy to adolescence; and they are imbued with a sense of benevolence, or even tenderness, that is seemingly rare in Cézanne's work.

The oil sketch of 1875 (fig.19) of a cherubic little boy, captured with touching immediacy, evolved from the artist's incessant drawings of his son, who often added his own childish illustrations to the pages of Cézanne's sketchbooks. Not surprisingly, the likenesses of Paul *fils* become more finished and composed as he matures and takes on the famously tortuous task of sitting as a subject for his father. The largest and most complete of these early portraits, *The Artist's Son* of 1881–2 (p.42), for example, is composed of a sophisticated series of reciprocal curves that unify the contours and features of the figure with his setting. Painted in limpid layers of pigment that highlight its graceful linear correspondences, it may draw as well on the rhythmic contours Cézanne had discovered in the paintings and sculptures he studied in the Louvre. But the artist's attachment to his subject remains palpable, and paramount, and suggests the depth of Cézanne's fluency in the art of portraiture that he so clearly sidesteps in some of his more mask-like paintings of Hortense.

Cézanne would test that tradition specifically in his *Mardi Gras* of c.1888 (fig.8). The strangely sober canvas, which

FIG. 8
Mardi Gras, c.1888

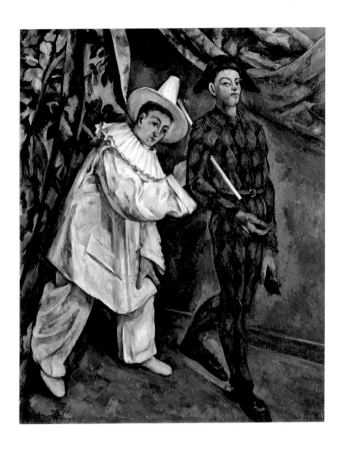

was preceded – unusually – by a number of highly finished preparatory studies, is one of his last of Paul *fils*, who is pictured with his friend Louis Guillaume. The painting is not a portrait, however, or even a double portrait, but rather a staged, studio production that challenges the very nature and realism of the genre. Its fanciful subject, a staple of street theatre, is built around the stock *commedia dell'arte* figures of Pierrot and Harlequin. In Cézanne's sequential drawings of his son in particular, and in the final painting, the demands of portraiture recede as Paul *fils* takes on the impudent stance and trademark sneer of the cocksure character, Harlequin. Cézanne's *Mardi Gras* became a touchstone for many later artists, who

PAUL CÉZANNE · PAINTING PEOPLE

recognised not only how thoroughly it codified the popular *commedia dell'arte* subject, but also how it generated a creative tension between the realist realm of portraiture and the artifice of theatre.

In the early 1890s Cézanne at last began to enjoy the taste of critical and commercial success, and his portraits pay homage to those who made it possible. In 1892 a short biographical sketch penned by the artist, writer and future disciple Emile Bernard, and a glowing account of his work by another painter and later adherent Maurice Denis, brought Cézanne much-needed new attention. A year later, the well-known art critic Gustave Geffroy cited his painting in short, laudatory articles, followed in 1894 with an enthusiastic monographic essay in the prestigious *Le Journal*.[7] Thanks in part to Geffroy's help, the art dealer Ambroise Vollard acquired a number of Cézanne's paintings and, in November 1895, organised a landmark retrospective exhibition, where his portraits were much in evidence. Among the eminent attendees were Monet, who would buy one of the *Boy in the Red Waistcoat* canvases, and Geffroy, who purchased one of the more sketch-like paintings of Madame Cézanne.[8]

Cézanne met Geffroy in late 1894 at a luncheon hosted by Monet that was attended by other critics and artists, including Auguste Rodin, and the following spring offered to paint his portrait. As has often been noted, Cézanne studiously emulated Degas's earlier portrait of Edmond Duranty (1879, fig.9), a novelist and critic who had boosted Degas's reputation. Both artists drew on the established motif of a scholar in his study, which Edouard Manet had updated in his flattering portrait of Zola (1868, fig.10). But unlike these earlier portraits, Cézanne's is sombre and aloof, and, in its unfinished state, speaks more to his subject's profession than his appearance (1895–6, p.54). The seated figure is anchored in a stable triangle at the centre and surrounded by a veritable still life of the props of his *métier*: books, an inkwell, flowers and a plaster figurine of Rodin's *Pomona*, a probable allusion to the critical support that Geffroy

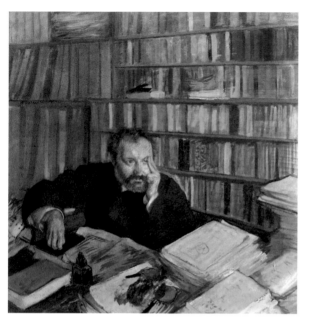

FIG. 9
Edgar Degas, **Portrait of Edmond Duranty**, 1879

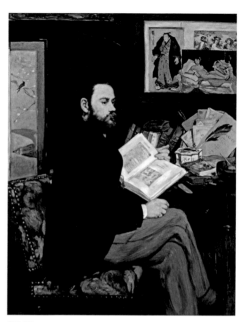

FIG. 10
Edouard Manet, **Portrait of Emile Zola**, 1868

had recently offered the sculptor.[9] As in many of the Madame Cézanne portraits, the face is opaque, painted thinly in muted tones of deep greys and purples that are enlivened by scattered touches of rose, orange and white. Geffroy clearly did not mind being rendered, rather than captured. The painting left its subject in awe of its 'richness of tone and incomparable harmony', despite his memories of the artist's painful efforts to complete it. Geffroy must have also recognised the mantle of genius Cézanne's painting conferred on him. The motif of the contemporary journalist or critic as an intellectual was everywhere apparent at the Salons of the 1890s and served to legitimise both their new profession and the vanguard art they endorsed. A few years later, in an equally formal and remote portrait that placed even greater demands on his sitter, Cézanne would bestow upon the dealer Vollard a similarly erudite stature (1899, p.68).

PAUL CÉZANNE · PAINTING PEOPLE

The portraits, which serve as tributes to Cézanne's growing network of support, share with his monumental late paintings of largely nameless labourers and Provençal peasants a sense of hieratic order and equilibrium that renders the subjects of these works heroic. In his majestic *Woman with a Cafetière* of *c.*1895 (p.59) the figure's immense, volumetric presence is magnified by the pictorial geometry of the panelling behind, but softened by painterly touches of pink in her face and weathered hands, and by the floral wallpaper at left. Indulging in the total control he enjoyed in his studio, and especially in still-life painting, Cézanne augments its emphatic order by including a still life at right, in which the rounded volumes of the cup and coffee press and the curiously upright spoon serve as an index to the figure's unshakeable formal design. Similarly, in his *Seated Peasant* (*c.*1899, fig.11), a solemn but magnificent icon of rural

FIG. 11
Seated Peasant, *c.*1899

FIG. 12

The Environs of Aix-en-Provence,
c.1859 (detail)

masculinity, a small still life at lower left of stacked books
and boxes and the diagonal of a painter's brush rehearse the
dominant lines of the portrait's steadfast composition.

In his final years, Cézanne brought to fruition the themes
he had pursued over the course of his career. The complexity
and autonomy of his elaborate late still lifes would make them
modern paradigms of the genre; his late Bathers, a curious
hybrid of fantastic figural and landscape painting, would
engender countless progeny; and Cézanne's paintings of
Provence would forever etch his native environs into the
annals of twentieth-century art. His late portraits also subsume
a career rife with struggle, ambition, doubt and, in the end,
consummate achievement. If, in his old age, Cézanne honours
his own history in the beautiful *Man in a Blue Smock* of c.1897
(p.67) – its background quotes from his earliest known work,
a tapestried screen he had decorated as a youth in Aix (c.1859,
fig.12) – the artist's contemplations of his imminent mortality
are bound up in the deeply moving late paintings devoted to his
aged gardener Vallier (1906, p.81). This final series of portraits

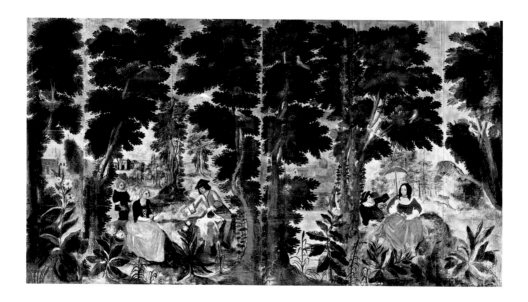

would inspire many of the painter's modern admirers, among them, notably, Martin Heidegger. At the close of his own long career, the German philosopher discovered Cézanne's painting, and marvelled, in an ode to the portraits of the humble Vallier, at Cézanne's ability to realise in the mute presence and 'urgent stillness' of the painted image the utter transformation of its subject.[10] Like Rilke decades before, Heidegger recognised the inadequacy of the standard criterion of the genre, that of verisimilitude, especially in Cézanne's gifted hands in which the portrait had become such a telling and powerful aesthetic vehicle. Cézanne's paintings of people, which would fundamentally transform the genre of portraiture in modern art, offer us today but one measure of his ineffable artistic genius.

'FWN' refers to Walter Feilchenfeldt, Jayne S. Warman and David Nash, *The Paintings of Paul Cézanne: An Online Catalogue Raisonné*; www.cezannecatalogue.com/catalogue/index.php

1 Theodore Duret, 'Les Peintres Français en 1867' (E. Dentu, Libraire-Editeur, Paris, 1867), p.132.

2 The earlier portrait of Louis-Auguste Cézanne is FWN 398 (National Gallery, London, *c*.1865). Guillemet quoted from his letter to Zola, 2 November 1866, in Alex Danchev, *The Letters of Paul Cézanne* (J. Paul Getty Museum, Los Angeles, 2013), p.129.

3 Degas purchased FWN 438 (Virginia Museum of Fine Arts, Richmond).

4 In addition to the exhibition catalogue, two superb recent publications have explored the portraits of Madame Cézanne in depth: Susan Sidlauskas, *Cézanne's Other: The Portraits of Hortense* (University of California Press, Berkeley, 2009) and Dita Amory, *Madame Cézanne*, exh. cat., Metropolitan Museum of Art, New York, 2014.

5 Letter to Clara Rilke, Paris, 22 October 1907 in Rainer Maria Rilke, *Briefe über Cézanne*, ed. Clara Rilke (Insel, Wiesbaden, 1952), pp.38–40.

6 Roger Fry, *Cézanne: A Study of His Development* [1927] (Noonday Press, New York, 1958), p.30.

7 Gustave Geffroy, 'Paul Cézanne' in *Le Journal*, 25 March 1894.

8 FWN 495 and 467 respectively.

9 See George Grappe, *Catalogue du Musée Rodin, I. Hôtel Biron* (Musée Rodin, Paris, 1927), no. 90; cited in Theodore Reff, 'Painting and Theory in the Final Decade' in *Cézanne: The Late Work* (Museum of Modern Art, New York, 1977), pp.20–1 (Rodin ills.), p.50, n.42.

10 On Heidegger and Cézanne, see Robert B. Pippin, *After the Beautiful: Hegel and the Philosophy of Pictorial Modernism* (University of Chicago Press, Chicago and London, 2014), pp.96 ff. Although it is not clear which portrait(s) of Vallier the philosopher may have seen, Pippin (p.121) includes the poetic tribute that appeared in Heidegger's *Gedachtes*:

*The thoughtfully serene, the urgent
Stillness in the form of the old gardener
Vallier, who tended the inconspicuous on the
Chemin les Lauves.*

*In the painter's late work the two foldness
Of what is present and of presence has
Become simple,
'Realized' and at the time intertwined,
Transformed into a mysterious identity.*

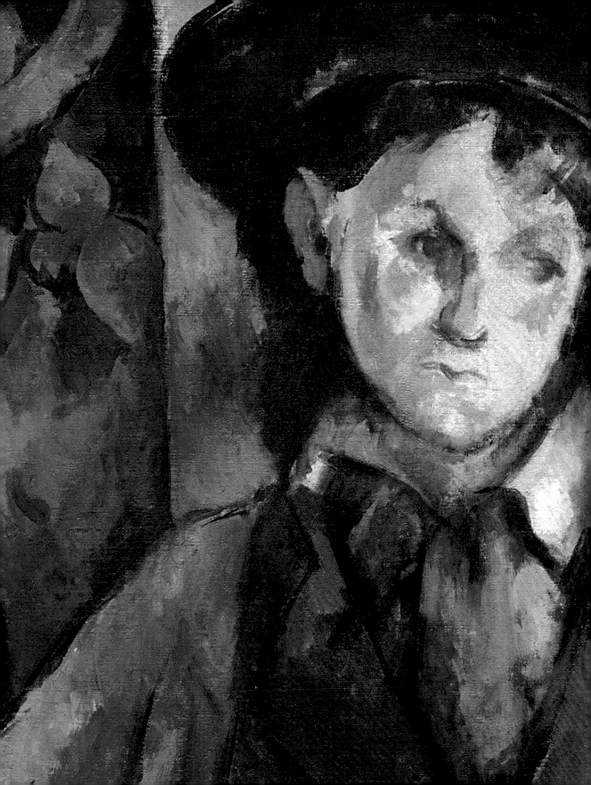

Painting
People

The Artist's Father,
Reading *L'Evénement*

1866
Oil on canvas 2000 × 1200mm
National Gallery of Art, Washington, D.C.

The artist's father, Louis-Auguste Cézanne (1798–1886), was the archetypal self-made man. The son of Italian immigrants, he settled in Aix-en-Provence and made his way first by selling hats and then by becoming a banker. He wanted the best for his son, a good education and a suitable profession. The shy and insecure Paul was the antithesis of his father, vacillating between the family business in Aix, a profession in law, and life as an artist in Paris. Yet Louis-Auguste would magnanimously underwrite his son for much of his life.

Cézanne's powerful portrait of his father, with its dramatic contrasts of light and dark, the paint confidently applied by means of a palette knife, is both a private and a public manifesto. On a personal level, Louis-Auguste is portrayed from a respectful distance, an imposing figure enthroned upon his armchair. Cézanne has woven himself into the domestic scene by including an early still life (1865–6, fig.2) on the wall behind. Yet the portrait also alludes to a wider public debate, for Louis-Auguste is shown absorbed in the pages of *L'Evénement*, the journal in which writer Emile Zola published his defence of artists rejected by the Paris Salon of 1866, of whom Cézanne was one. Ironically, this work would be his only painting to be accepted by the Salon, exhibited as *Portrait de M.L.A.* (1882).

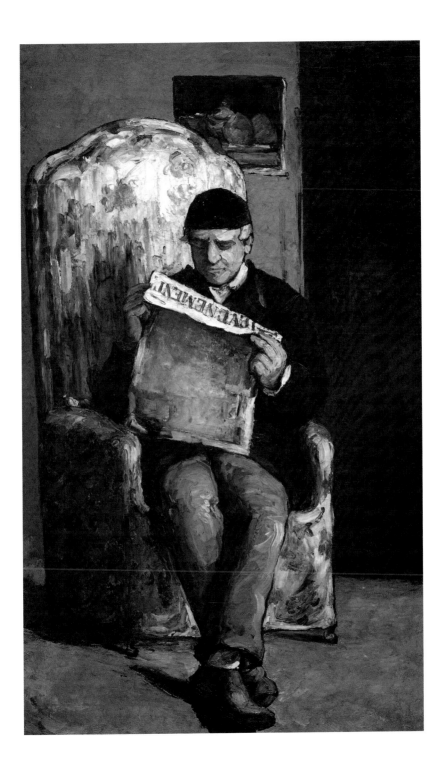

Uncle Dominique as a Lawyer

1866–7
Oil on canvas 620 × 520mm
Musée d'Orsay, Paris

From August 1866 to February 1867, while living at the Jas de Bouffan, his father's estate near Aix-en-Provence, a young Cézanne embarked on a series of paintings of his uncle, the bailiff Dominique Aubert (b.1817). He made a set of some ten portraits: six small portrait heads and four larger, half-length figures in varying costumes, of which this is one.

His output was extraordinarily rapid, with a new portrait of Uncle Dominique appearing almost every day. Common to all these works is their aggressive palette-knife technique, which Cézanne later referred to as his *manière couillarde* (or 'ballsy' style). It is reminiscent of that of the Realist artist Gustave Courbet, whose work Cézanne was familiar with, and whose rebellious behaviour he copied. However, Cézanne's innovation was to use this style for painting portraits; as a means of structuring the figure, building it up step-by-step much as one might plaster a wall.

Here Uncle Dominique is dressed as a lawyer, the profession Cézanne's father had intended for his son and which he duly rejected, a hint at self-identification perhaps. The figure exhibits a solemn monumentality, emphasised by the contrast between black court attire and white background. Such costume pieces were a feature of historicist paintings and reflect the satirical side of Provençal culture, which revelled in mocking establishment figures, particularly those in the legal and ecclesiastic professions.

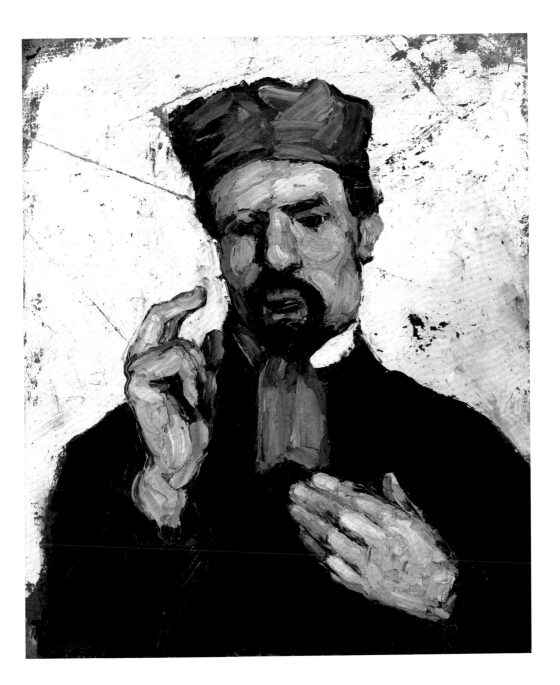

Antony Valabrègue

1869–70
Oil on canvas 600 × 502mm
J. Paul Getty Museum, Los Angeles
(see also detail, p.94)

When a jury member at the Paris Salon of 1866 saw Cézanne's earlier portrait of the poet and art critic Antony Valabrègue, he exclaimed that the portrait was not painted with a knife but with a pistol. Although the Salon refused to show the work, Cézanne continued to paint many portraits of his friend, including this canvas, painted between 1869 and 1870.

A member of a local group of aspiring artists and writers in Aix that included Emile Zola and Achille Emperaire, Valabrègue (1844–1900) was from a well-respected Jewish family that had been established in Provence for generations.

Half the size of the ambitious, public work submitted to the Salon, this head-and-shoulders portrait is less formal and shows Valabrègue looking relaxed, his hair tousled, jacket open. Cézanne continues to apply paint in thick successive layers, structuring the face by means of highlights and creating contours with dark tones. But his use of loaded brushes as well as the palette knife now suggests a more refined surface overall, less aggressive in its treatment than, for example, his portrait of his father (p.26).

Cézanne would paint Valabrègue at least once more in the mid-1870s, possibly when they both returned to Aix during the summer of 1874.

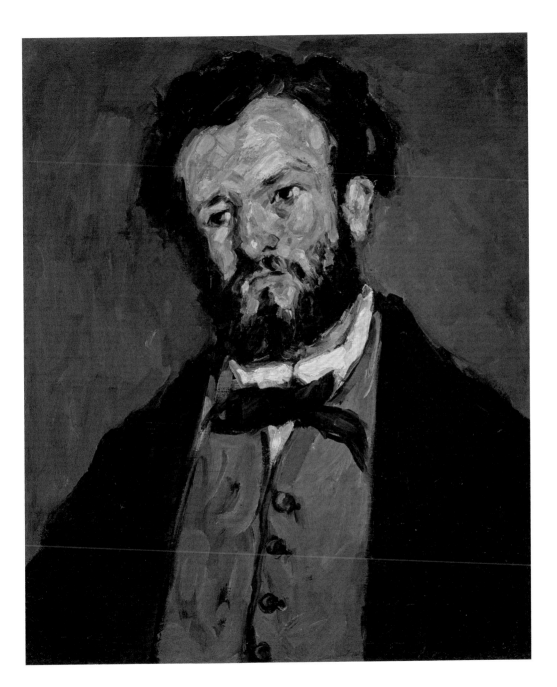

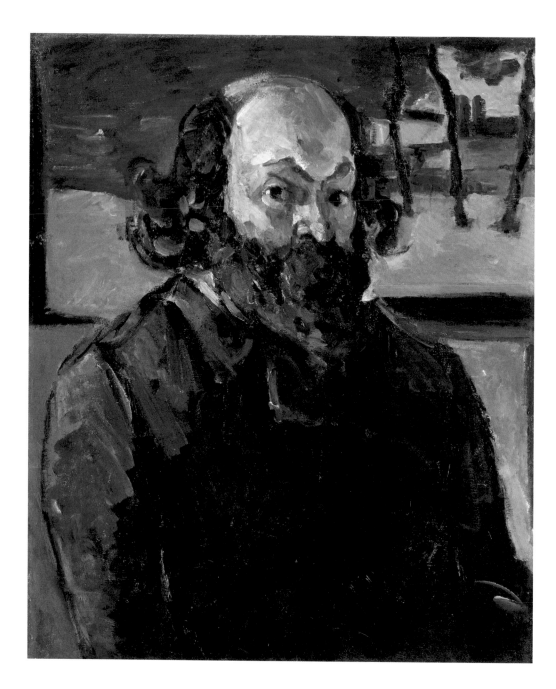

Self-Portrait

*c.*1875
Oil on canvas 640 × 530mm
Musée d'Orsay, Paris

Cézanne painted self-portraits throughout his artistic career.
This particular example represents a return to the genre
after an initial foray in the 1860s. He would continue to make
self-portraits until a few years before his death. As such,
they have an autobiographical value, tracing his outward
development from the somewhat unruly, wild figure in
his mid-thirties shown here, to increasingly contemplative
representations. His inner self, however, is more difficult
to read.

This work, in which he sculpts the face with thick,
overlapping brushstrokes, may have been made in the studio
of artist Armand Guillaumin at the quai d'Anjou in Paris.
While occasionally Cézanne worked from a photograph, this
canvas is one of many that he painted by means of a mirror;
his direct gaze thus meets ours face to face. Indeed, he seems
to have provided a clue as to how he painted the work:
Guillaumin's *View of the Seine, Paris* (1871, fig.3), the landscape
that appears in the background, is reversed.

There is a somewhat staged, performative feel to this
work, in which Cézanne portrays himself with unkempt
hair, bushy beard and clothes that occupy a middle ground
between bourgeois and peasant. It echoes a self-portrait by
Camille Pissarro, perhaps testifying to his close professional
relationship as well as personal friendship with both
Guillaumin and Pissarro.

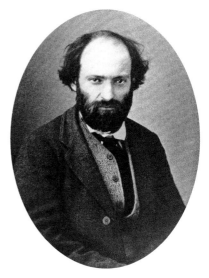

FIG. 15
Paul Cézanne, photograph, *c.*1875

Victor Chocquet

1877
Oil on canvas 460 × 380mm
Columbus Museum of Art, Ohio
(see also detail, p.37)

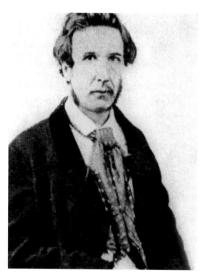

FIG. 16
Victor Chocquet, photograph, c.1860

Victor Chocquet (1821–91) became not only Cézanne's patron but also his close friend and confidant. A customs official by profession, he was not a wealthy man but through careful selection he became one of the most important private collectors of the nineteenth century. He was introduced to Cézanne by Renoir in 1875 and the two discovered a shared love of the works of Delacroix and Courbet.

As Cézanne began to paint Chocquet, Chocquet began to collect Cézanne. Over fifteen years he amassed some thirty-five works, from small sketches to masterful canvases. This work shows Chocquet in his Parisian apartment on the rue de Rivoli, surrounded by his paintings. He sits in a Louis XIV armchair and gazes steadily at the artist. His interlaced fingers, crossed legs and the frontal pose of his head and torso reinforce a balanced composition, while the decorative design of the wallpaper, the bright upholstery and the patterned rug create a colourful vibrancy. Cézanne builds up the surface of the canvas into a unified mosaic of horizontal and vertical brushstrokes, a practice he continues to develop in *Madame Cézanne in a Red Armchair* (p.39) of the same period.

The portrait expresses the serene stability that Cézanne ascribed to Chocquet's character. He would paint his patron many more times and they remained close friends until Chocquet's death.

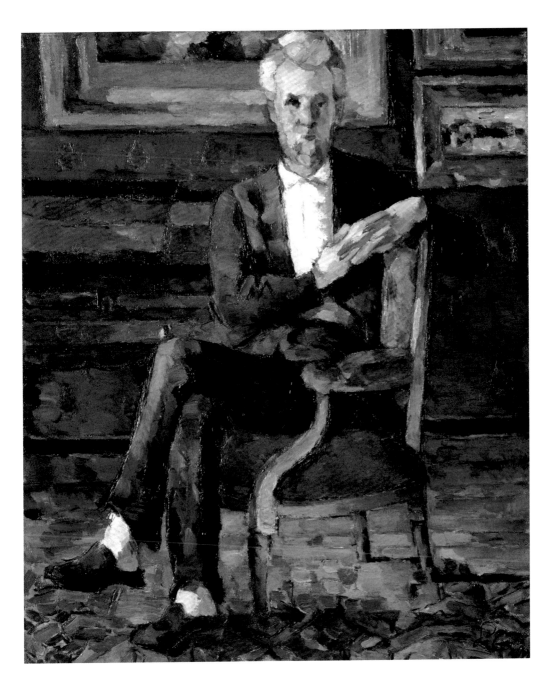

He builds up the paints, which he mixes and grinds with extraordinary ardour, going back over the thicknesses to nuance the tone; sometimes his touch follows the sense of the form, sometimes it is a long slash, but it always carries with it sombre, plentiful pigment, sculpted with an energetic lightness.

Henri Focillon, *La Peinture au XIXe siècle*, 1928

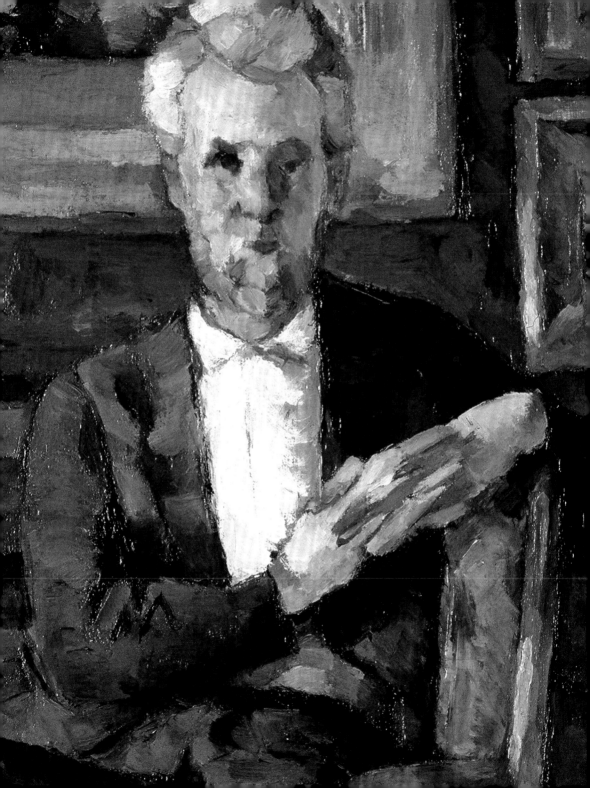

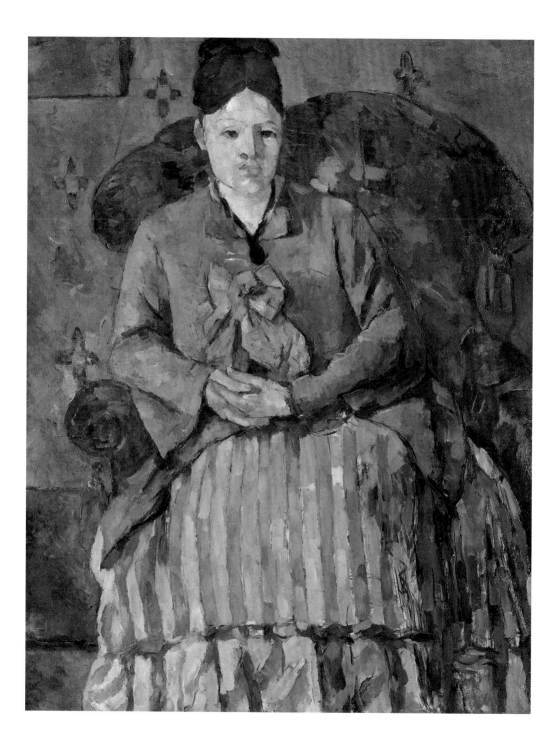

Madame Cézanne in a Red Armchair

*c.*1877
Oil on canvas 725 × 560mm
Museum of Fine Arts, Boston
(see also detail, p.6)

This work is amongst the earliest of nearly thirty portraits that Cézanne painted of his lover and eventual wife, Hortense Fiquet (1850–1922). It was made in their Paris apartment on the rue de l'Ouest, where they lived with their young son Paul. (Hortense, like Cézanne, was from the provinces, but moved to the city with her parents who were in search of employment.) Infused with a peaceful radiance, this portrait reflects their settled family life at this time.

Hortense appears regal yet gentle, as her figure relaxes into the yielding contours of the high-backed armchair in which she sits. Her face is modelled by flat planes of sumptuous colour that contrast with the red upholstery. Influenced by Paris fashions, she wears a blue *robe de promenade*, decorated with ribbons and with a shimmering striped skirt. In describing its form, textures and tonality, Cézanne surpassed his earlier work. This sympathetic portrait captures the rapport between sitter and artist, suggested not so much by the sitter's gaze as the artist's responsive brushwork.

During the late 1870s traditional portrait paintings filled the walls of the Paris Salon, and portrait photography was booming. By shifting the focus of the portrait away from notions of likeness and identity and towards composition and the pleasures of colour, Cézanne was able to uphold the aesthetic aspects of the genre.

FIG. 17
Hortense Fiquet, later Madame
Cézanne, photograph, *c.*1905

Self-Portrait

1880–1
Oil on canvas 336 × 260mm
National Gallery, London
(see also detail, p.82)

FIG. 18
Paul Cézanne, setting out to
paint *sur le motif* ('before nature'),
near Auvers, photograph, c.1875

Cézanne entered a new phase in his career in the early 1880s,
having refused from 1879 to take part in the Impressionists'
exhibitions and hoping (though succeeding only once) to
be accepted at the official Paris Salon.

His work now reflects a sense of calm. In this self-portrait
he is dressed like a middle-class *bon bourgeois*, his beard neatly
trimmed. His choice of an interior as the setting structures
the composition and distances it from the atmosphere
of a working studio. Here, we see Cézanne employing his
'constructive brushstroke' technique, applying small patches
of paint in a parallel, usually diagonal, direction. It is apparent
across his face and, in a more generalised fashion, across his
coat and the background. The contrast between the organic
volume of his head and the flat plane of the olive wallpaper
behind it is marked, yet made more complex by the curve
of his shoulder, which meets a vertical line that is promptly
broken by the locks of his hair. Conversely, the zig-zag
of the coat's lapel and the angular lines of the wallpaper
echo each other.

After a period of family dissension, Cézanne's father
began to look more favourably on his son's artistic ambitions,
and a few years later would build a studio for him at the
Jas de Bouffan, the family estate in Aix.

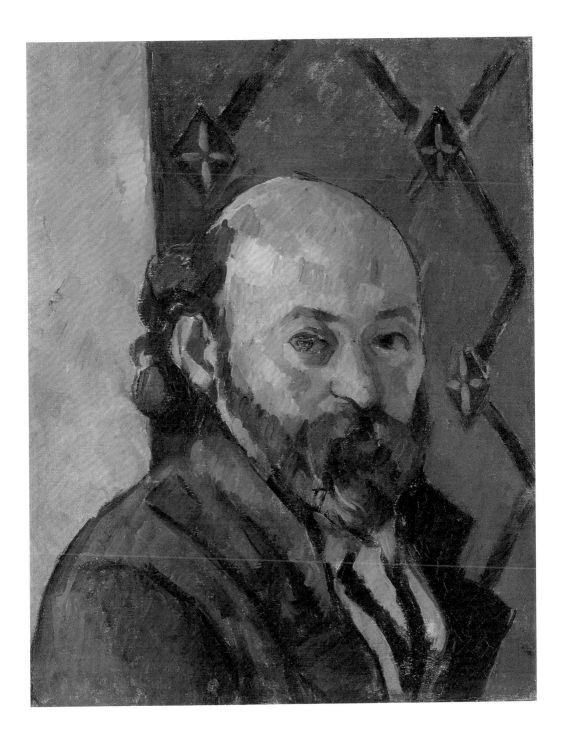

The Artist's Son

1881–2
Oil on canvas 350 × 380mm
Musée de l'Orangerie, Paris

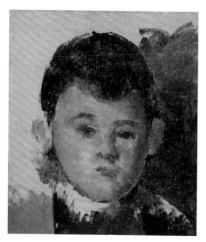

FIG.19
The Artist's Son, oil sketch, 1875

Cézanne produced a number of portraits of his son Paul
(1872–1947), nicknamed 'Le Boulet' or 'little dumpling'.
Although he often lived apart from his wife and son, Cézanne
doted on Paul *fils*, filling his sketchbooks with drawings and
oil studies, visual records of his young son as he grew up.
This portrait is perhaps one of the most ambitious and
the most accomplished of Paul *fils*, to whom he remained
close to the end of his life.

Typical of his experimental work of the early 1880s,
Cézanne here uses highly simplified forms with defined
contours. The composition is based on an interplay of curves:
those of the family's red upholstered armchair, the shoulders
and neck of the young boy, the neat sweep of his hair, and
the arc of his perfectly shaped eyes and eyebrows. There is a
strong contrast between the dark tones of the armchair and
the pale blue-grey background. The picture marks a shift in
Cézanne's technique at this period away from heavy oblique
brushstrokes towards thinned paint, loosely applied.

This work is one of a group of portraits of young boys,
including the Italian Michelangelo de Rosa (1888–90, p.51),
and the son of his friend and neighbour Antoine Guillaume,
which achieved a level of abstraction unparalleled in art
at that time.

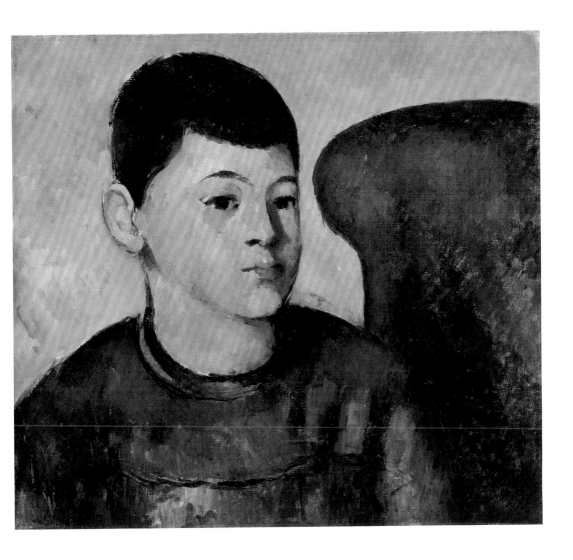

Self-Portrait with Bowler Hat

1885–6
Oil on canvas 445 × 355mm
Ny Carlsberg Glyptotek, Copenhagen

This is one of two painted self-portraits that show Cézanne wearing a bowler hat, his favourite headgear in later years. Cézanne clearly found its shape appealing, and it reflects his pleasure in modelling simple, solid geometric forms. This work shows the artist in a familiar pose, looking back over his shoulder, his right eye engaging with ours. The light tones of the loosely hatched background contrast dramatically with the blacks of his hat and jacket. His head, however, is carefully constructed with the parallel brushstrokes characteristic of the 1880s, the sweeping line of his brow echoing the curved brim of his hat.

The appearance of the bowler hat may have biographical significance. Not only has it been associated with his father's early hat-making profession, but on 28 April 1886, in Aix, he finally married Hortense Fiquet. In December of that year his father died, leaving him an inheritance. With the affirmation of his relationship with Hortense, the legitimising of his son, and newly acquired financial means, Cézanne was no longer living on the fringes of society but had become an eligible member of the bourgeoisie. As such, the hat can be seen to symbolise a respectable Cézanne in his late forties – the opposite of how he had presented himself in the self-portraits of his early twenties.

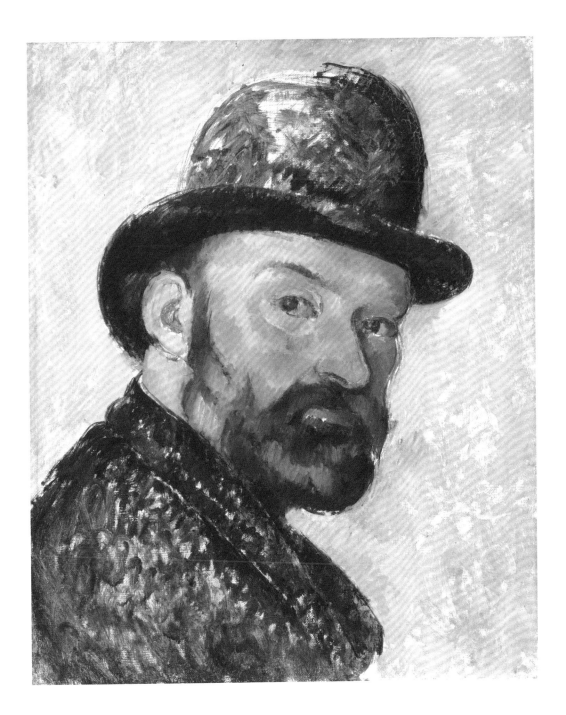

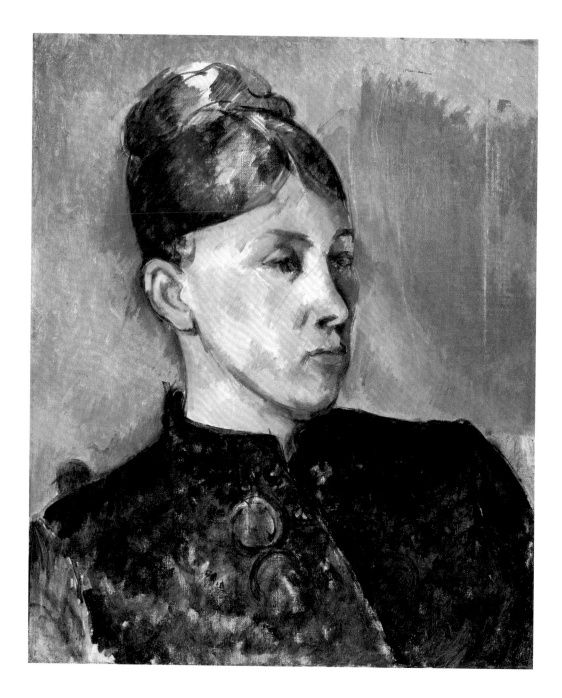

Madame Cézanne

1885–6
Oil on canvas 460 × 380mm
Philadelphia Museum of Art

Compared to the gentle figure enthroned on her red
chair (p.39), painted some eight to nine years earlier, this
conventional three-quarter pose presents a very different
Madame Cézanne. Painted at around the time of their
marriage, it forms one of a group of canvases of her that
mark a major change in Cézanne's portraiture. Emotion, in
this instance one of barely concealed displeasure, is shown
not only through facial expression but also the choice of
pose; and it is implied in the responsive brushstrokes
and use of colour.

A feeling of impatience pervades the picture. The surface
of Madame Cézanne's brocade dress is shown as shimmering
pattern to the left but darkens abruptly to the right. The
hurried treatment of the dress extends to her face, which
is made up of unblended diagonal patches, and her hair is
even more informally painted.

The leap in tonal values, combined with the sharp tilt of
the dress fastening and continued by the angle of her head,
effectively turns the figure away from us – and the artist.
We do not know if the sense of disquietude in this portrait
communicated itself from sitter to artist, or the other way
around; or even if the pose was staged. What is significant,
though, is the way in which emotion is depicted, and with
such energy.

This work would later be acquired by Henri Matisse.

Madame Cézanne in Blue

1886–7
Oil on canvas 735 × 610mm
Museum of Fine Arts, Houston

Cézanne finally acknowledged his relationship with
Hortense Fiquet, and they were married in Aix in 1886.
However, years of living incognito with their son, with
little financial or domestic stability, and constantly moving
between apartments in Paris and the South of France had
taken their toll. Even though now legally husband and
wife, and financially secure, they would not live together
as a family.

Cézanne's portraits of Hortense in a blue dress (this is
one of three) are among the most uncompromising of her.
Far from being presented as an idealised beauty, she appears
striking in her plainness, her hair pulled back severely; her
face is turned fully towards us, her gaze direct. Less engaged in
an investigation of character, the artist seems more absorbed
in the relationship of forms, through contrasts of light and
shade, the dark shapes of the sideboard and wallpaper to one
side vying with the pale verticals of the moulding to the other.
Subtle tensions are set up between the figure of Hortense
and the space that surrounds her.

Yet her presence is convincing, and we sense not only her
melancholy, as presented to the painter, but also the painter's
understanding of her state of mind.

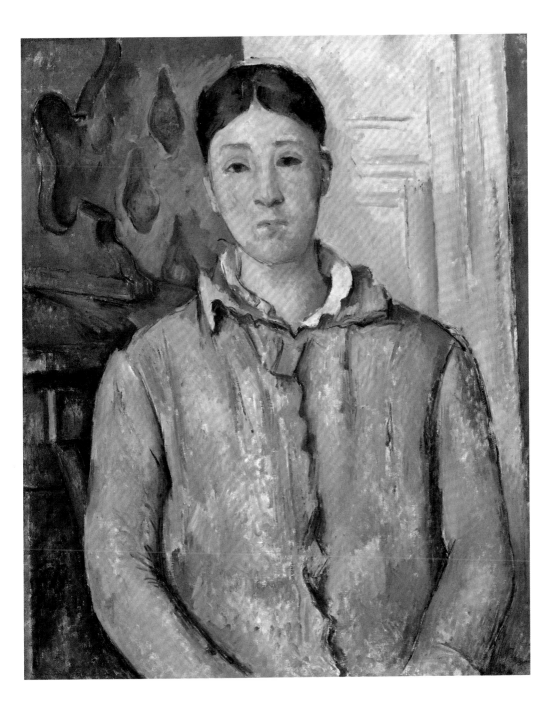

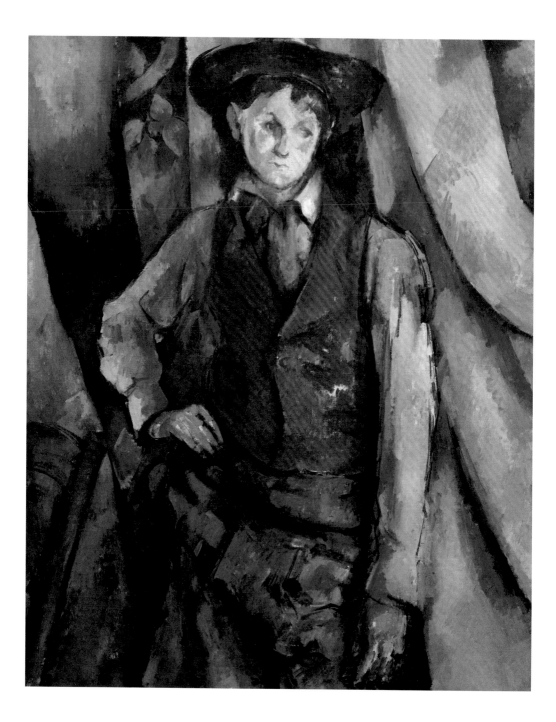

Boy in a Red Waistcoat

1888–90
Oil on canvas 920 × 730mm
National Gallery of Art, Washington, D.C.
(see also detail, pp.24–5)

Between 1888 and 1890 Cézanne made a series of paintings of a young boy, the model Michelangelo de Rosa, in the romantic costume of an Italian peasant. In each work, we sense a boy who is leaving childhood behind but has yet to reach maturity. Here, in this larger work (left) his classical pose and languid elegance suggests the influence of sixteenth-century Florentine Mannerists, whose paintings Cézanne would have known from hours spent studying the Old Masters in the Louvre.

The sittings took place in Cézanne's rented Parisian apartment on the quai d'Anjou. The confidence suggested by de Rosa's pose is belied by the pensive look on his young face. The symmetry of the boy's figure is enlivened by the serpentine contour of his waistcoat lapel and button seam, which sets up a rhythm that carries on through head, shoulders, hips and knees, and is echoed in the swag of the curtain behind. The chair back to his right acts as a counter-balance. Cézanne's orchestration of pattern and colour grew out of his response to his subject: in the boy's face and shirt the tones are mostly cool and remarkably varied — pinks, greens, lavenders, blues and purples — in contrast to the reds of his waistcoat.

This work received high praise when exhibited at Cézanne's solo show at Ambroise Vollard's gallery in Paris in 1895.

FIG. 20
Boy in a Red Waistcoat, 1888–90

Madame Cézanne in a Red Dress

1888–90
Oil on canvas 1160 × 890mm
Metropolitan Museum of Art, New York
(see also detail, p.90)

Of the four portraits that Cézanne painted of his wife wearing a shawl-collared red dress, this is the only one to show her in an elaborately furnished interior. Seated in a high-backed, yellow-upholstered chair, and wedged between well-placed props that seem to bend to her form and shift to her weight, Madame Cézanne is the lynchpin of a giddily tilting, spatially complex composition. Yet for all this movement, she is in command of her space. The mottled blue wall, the dark band that edges the chair rail, and the mirror over the fireplace to her right, identify the setting as 15 quai d'Anjou, the Paris apartment that Cézanne rented from 1888 to 1890.

Hortense wears a house dress typical of the kind that most bourgeois women would have worn. But its vivid red tones, together with her motionless pose, do not suggest domestic activity. Full-face and aloof, she stares at us with her right eye, but looks past us with her left. Her figure forms a strong triangle in the centre of the work, her dress divided firmly down the centre, a line that is echoed in the treatment of her face: one side older and in shadow; the other lighter and youthful. But both sides emerge equally through the process of paint.

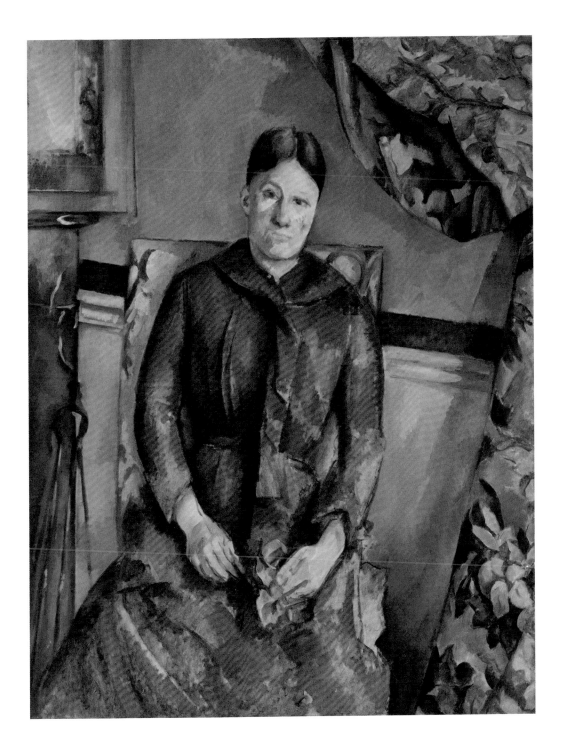

Gustave Geffroy

1895–6
Oil on canvas 1160 × 890mm
Musée d'Orsay, Paris
(see also detail, p.57)

FIG. 21
Gustave Geffroy, portrait photograph
by Nadar (Félix Tournachon), n.d.

Cézanne had faced the wrath of the French press during the 1870s. In fact it was not until 1894 that critical acclaim for his work began to gather momentum – with a review by Gustave Geffroy (1855–1926) in the prestigious *Le Journal*. To show his gratitude, Cézanne offered to paint the critic's portrait. It was an established practice for a writer to be painted by the artist he was supporting: Emile Zola was portrayed by Manet (1868, fig.10), Edmond Duranty by Degas (1879, fig.9). Cézanne planned to show Geffroy as a man of letters, surrounded by his books. He sat for Cézanne almost daily for three months, Geffroy commenting favourably on the work. But the artist felt unable to conclude the portrait. It remained unfinished.

Unusually for Cézanne, both this work and the portrait of Madame Cézanne (p.52) show the sitter participating in their own environment rather than situated in a neutral context. Geffroy is portrayed as part of a still life: the figure forms a strong triangle in the centre while the shelves of books behind him rise and bend. Once again the sitter's surroundings are in motion. But here we sense slower, repeating rhythms that have briefly paused. The bold use of space on the table's surface, filled with open volumes, may have caught the attention of future Cubists at the 1907 Salon d'Automne.

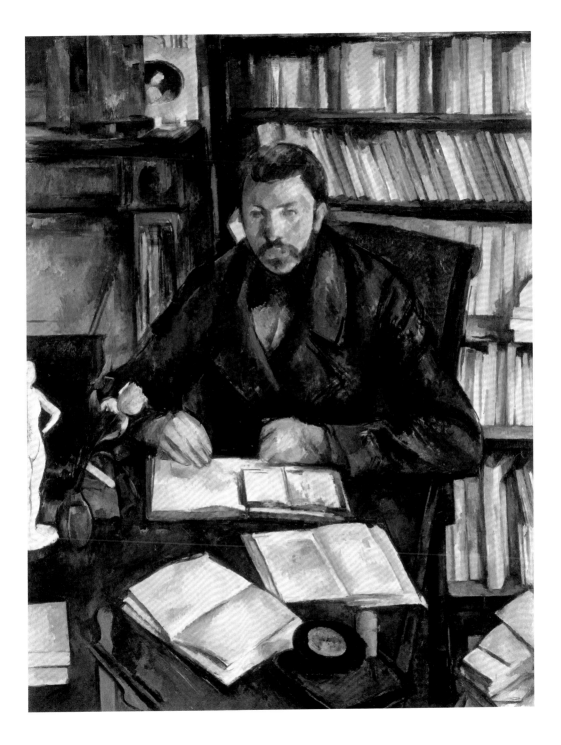

For Geffroy, his portrait, despite remaining unfinished, was one of Cézanne's most beautiful works:

The library, the papers on the table, Rodin's little plaster model, the artificial rose which he brought at the beginning of our sittings, everything is first rate. There is also a person in the scene, painted with meticulous care and richness of tone, and with incomparable harmony. He had only sketched in the face. And he would always say, 'We'll leave that for the end.' Sadly, there was no end.

Michael Doran (ed.), *Conversations with Cézanne,* **2001**

FIG. 22
Gustave Geffroy in his study,
photograph, c.1894

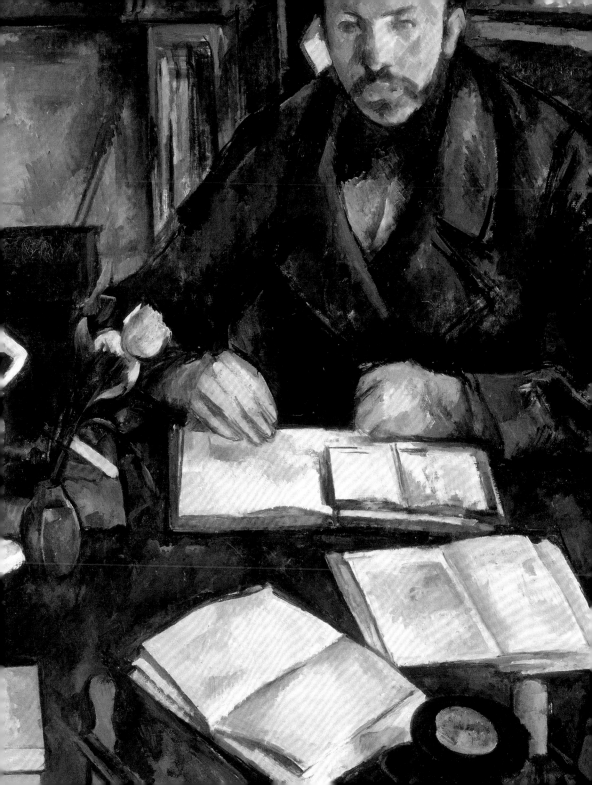

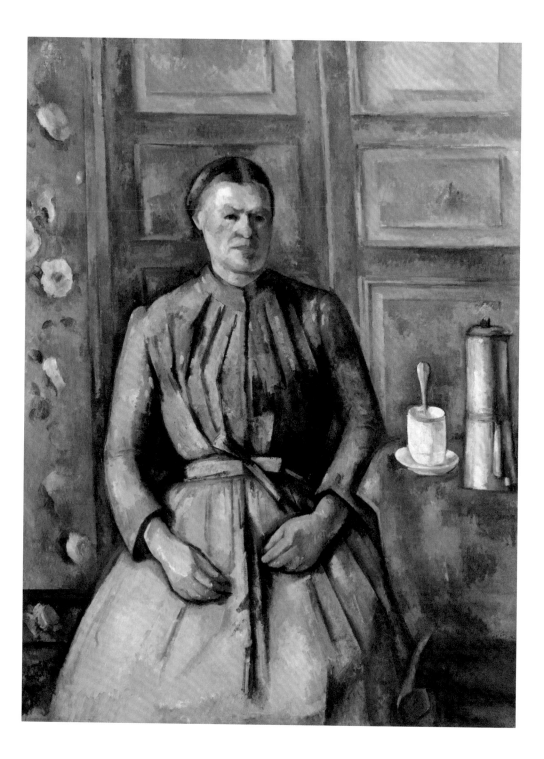

Woman with a Cafetière

c.1895
Oil on canvas 1300 × 970mm
Musée d'Orsay, Paris

The model for this portrait is unknown but she represents
the *Aixois* character that Cézanne held in esteem, her
hands roughened by manual work, her face plain but
dignified. Cézanne preferred to work with his family, or
friends he knew well, or local people who, out of respect
or remuneration, were prepared to offer the artist the
patience he required.

Once more, Cézanne shows his subject in a familiar
environment, probably the kitchen at the Jas de Bouffan,
with its panelled doors; an oilcloth covers the table on which
rest the *cafetière* and a cup and saucer with spoon. The main
elements in the composition are treated geometrically – the
triangular form of the figure is placed against a background of
horizontal and vertical lines, contrasting with the cylindrical
shapes of the cup and the *cafetière* – while the slant of the table,
seen from a higher angle than the objects upon it, heralds the
Cubist movement to come. This work illustrates Cézanne's
comment to painter and critic Emile Bernard, in 1904, that
nature should be portrayed by means of the cylinder, the
sphere and the cone. But geometry is offset by the irregular
flowers of the wallpaper, the highlights on her dress and
the folds of the cloth; and the subject is portrayed with an
empathy that makes the work more than a study of forms.

FIG. 23
Study for *Woman with a Cafetière*,
c.1895

Old Woman with a Rosary

1895–6
Oil on canvas 806 × 655mm
National Gallery, London

Character studies, in particular of local country people, were a major part of Cézanne's work from around 1890, and his late paintings of *Aixois* peasant women are notable for their sombre presence. This work portrays a sitter whose features reflect a life of manual labour and whose piety went with the territory (the artist himself renewed his faith in the Catholic Church in the last decade of his life). An unlikely story, attached to this work by its first owner, the poet Joachim Gasquet, relates that the sitter was a former nun who, aged seventy, had lost her faith, abandoned her convent and, having become destitute, had been given shelter by the artist in an act of charity. She was in fact a former servant of lawyer Marie-Joseph Demolins.

She is dressed in typical servant's attire: blue dress, black shawl and frilled cap. Cézanne may have felt a certain nostalgia for a way of life that was disappearing in the face of modernisation. But this is not a work of pathos; instead it shows psychological insight. Cézanne has chosen to portray her clutching her rosary, but rather than appearing contemplative and in prayer, we see her troubled and disconnected self.

Cézanne worked on the painting continuously for eighteen months, but after much reworking, he abandoned it.

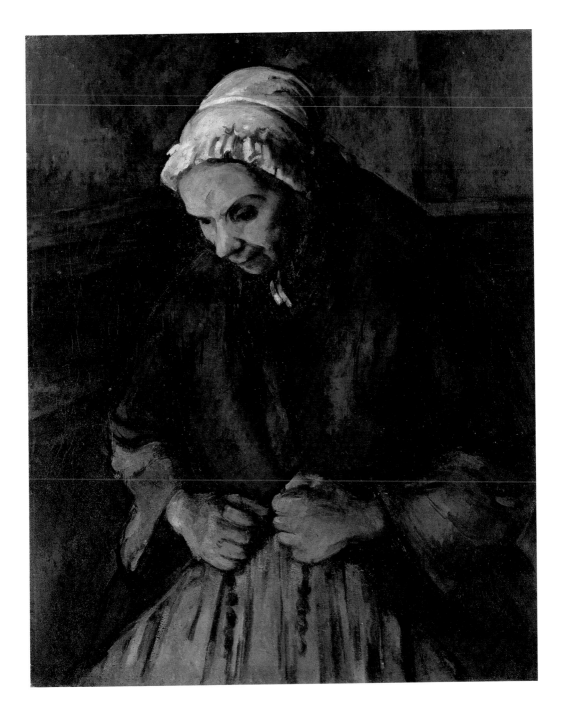

Child in a Straw Hat

1896
Oil on canvas 689 × 581mm
Los Angeles County Museum of Art

Cézanne rarely made portraits of children, unlike the
Impressionists in whose work they often featured
prominently. Yet after 1895 he painted five portraits of children,
of which this is one. Perhaps they offset his increasing
preoccupation with old age in his later years.

In 1896 Cezanne spent a second summer vacation in
French Switzerland with his wife and son. The first, in 1890,
had not been a success; nor, it seems, was this trip. He
missed Aix and painted to relieve his boredom. The child
in a straw hat shown in this work is thought to be the son
of a Monsieur Vallet, one of the gardeners at the Hôtel de
l'Abbaye where they were staying – a former monastery
in Talloires, on the shores of Lac d'Annecy.

Cézanne was experimenting with his use of parallel
brushstrokes, which are apparent here in the vertical lines of
the panelling and door in the background and in the pleated
smock of the child. Within this constructed framework, the
colours are soft and subtle: to one side, they range from a
pinkish-grey to a bluish-grey and a cool grey-green; to the
other, a warm orange pervades. The simplicity of both the
composition and colour tonality formalises a subject that
could have become sentimental, yet in Cézanne's hands
assumes a contemplative innocence.

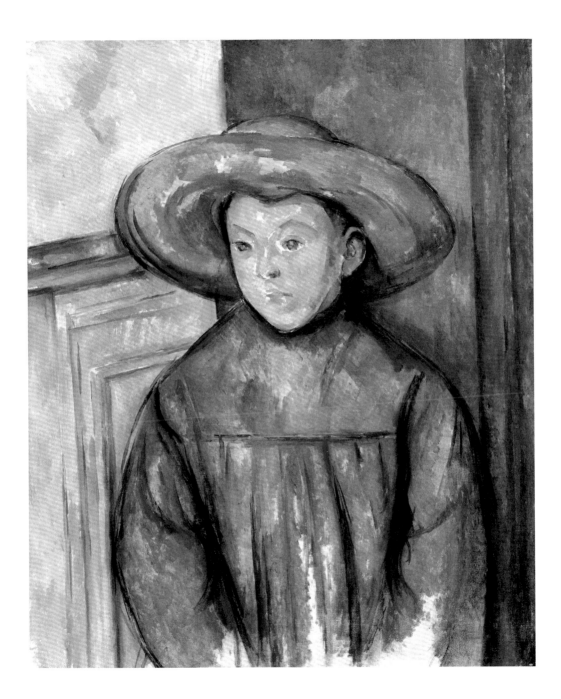

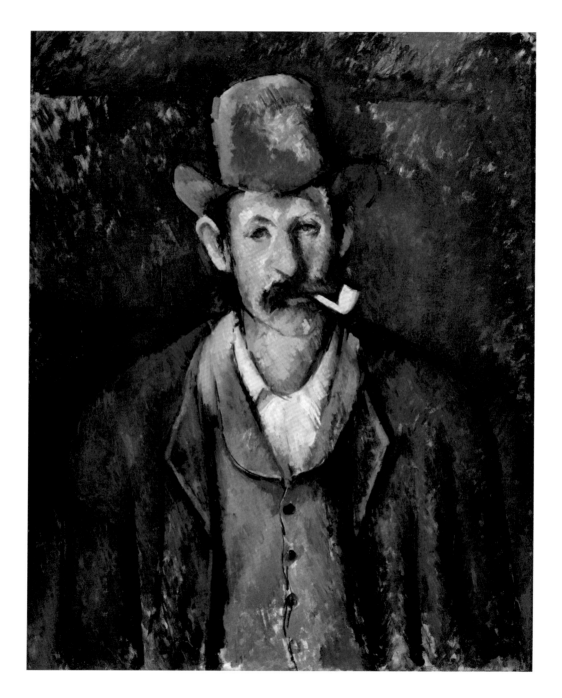

Man with a Pipe

1891–6
Oil on canvas 730 × 600mm
Samuel Courtauld Trust, Courtauld Gallery, London

In the later 1890s Cézanne returned to an earlier subject, that of *Aixois* peasants, producing some six works up to 1904–6. Not only were his sitters available as subjects, they also represented aspects of Aix that Cézanne revered. His love of the region and its inhabitants intensified as his views of the Parisian city dweller became more negative. Unlike more conventional images of peasants that romanticised, or demeaned them, Cézanne's portraits bestow a heroic status. With no pressure to produce a recognisable likeness, these works left the artist free to challenge stereotypes.

This sitter represents Cézanne's single peasant theme. We know very little about him, though he is recognisable from an earlier appearance in Cézanne's two-figure Card Players series. He may have been a farm worker at the Jas de Bouffan, the family estate. His clothing is simple and shapeless, his pose restrained. He is placed squarely at the centre of the canvas, his head turned slightly to the left while his gaze is direct. His broad, sloping shoulders almost fill the width of the picture, defined by dark contours against the sketchily painted background. The earth tones of the portrait may suggest the rugged topography of Provence, but the vitality of the artist's colour palette is ever present.

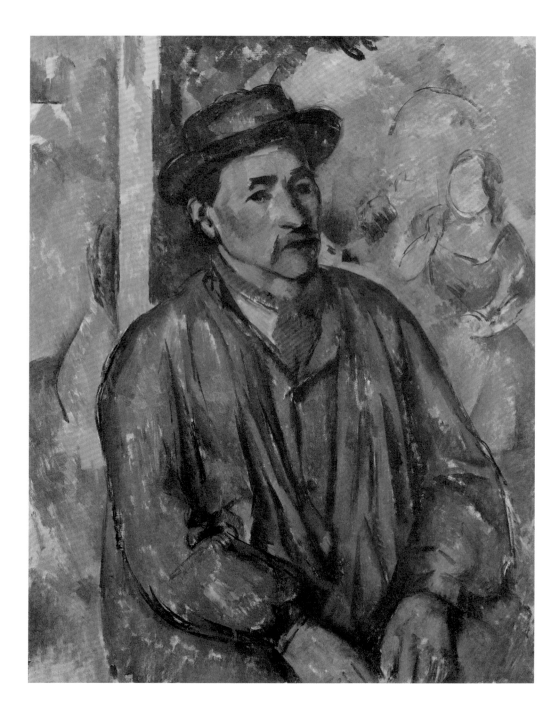

Man in a Blue Smock

*c.*1897
Oil on canvas 815 × 648mm
Kimbell Art Museum, Fort Worth, Texas

Another of Cézanne's late peasant portraits, this work
shows a farm worker from the Jas de Bouffan, probably
Père Alexandre. He also appears in the background of two
of Cézanne's Card Players compositions, yet apart from
acting as studies for genre compositions, these single peasant
portraits stand in their own right. Dressed in a blue smock
and red neckerchief, Père Alexandre seems emblematic of the
Aix countryside. However, this later portrait is more complex,
with slivers of unpainted canvas enlivening the solidity of
the early 1890s peasant portraits.

Cézanne's nostalgic, Arcadian attachment to his native
landscape and its people is suggested by the decorative
screen that forms the background to this work and to which
he added figures of his own as a young artist (*c.*1859, fig.12).
This was a scene of leisure rendered in the pastoral spirit of
an eighteenth-century tapestry. Juxtaposed in an ambiguous,
possibly humorous way next to the rural worker, the elegant
but faceless figure of a woman with a parasol perhaps
suggests some silent dialogue between the sexes, differing
social classes, or even between the artist's earliest and most
fully evolved efforts as a painter.

Ambroise Vollard

1899
Oil on canvas 1010 × 810mm
Musèe de la Ville de Paris,
Petit Palais, Paris
(see also detail, p.70)

Ambroise Vollard (1868–1939) was a glittering figure on the art-dealing scene in Paris in the late 1890s. He staged a major exhibition of Cézanne's works in 1895, after which the artist started to gain due recognition.

Some four years later Cézanne would paint his portrait. Thereafter the art dealer would often pose for portraits by artists whose careers he had encouraged, but Cézanne's painting is the first of these works. This three-quarter-length portrait, one of the larger canvases that characterised Cézanne's later works, shows Vollard seated in the artist's studio in the Villa des Arts at 15, rue Hégésippe-Moreau.

By all accounts the result of great labour – Vollard claimed he sat for over 100 sessions, with Cézanne insisting that he remain as motionless as an apple – the impression is one of naturalness. This work, in which the artist adopts a triangular structure with subdued colour tonality, illustrates how he would set down and adjust patches of colour in order to modulate form.

Yet the portrait once again remained unfinished, Cézanne declaring that he was not displeased with the shirt front.

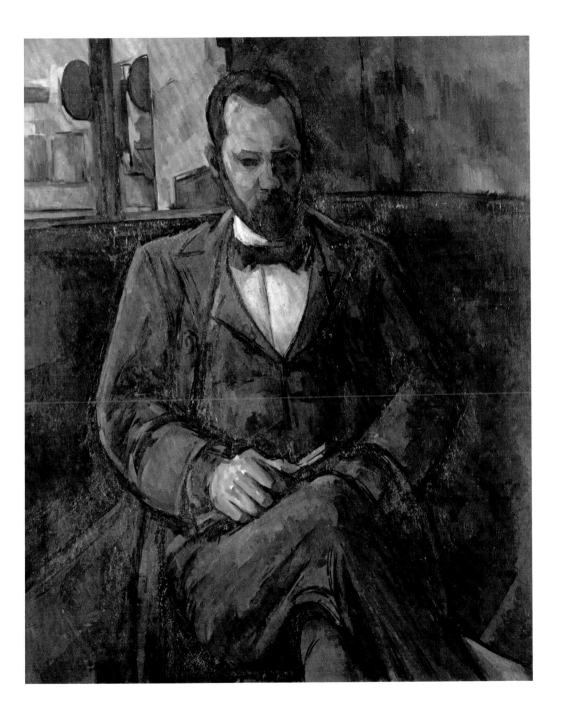

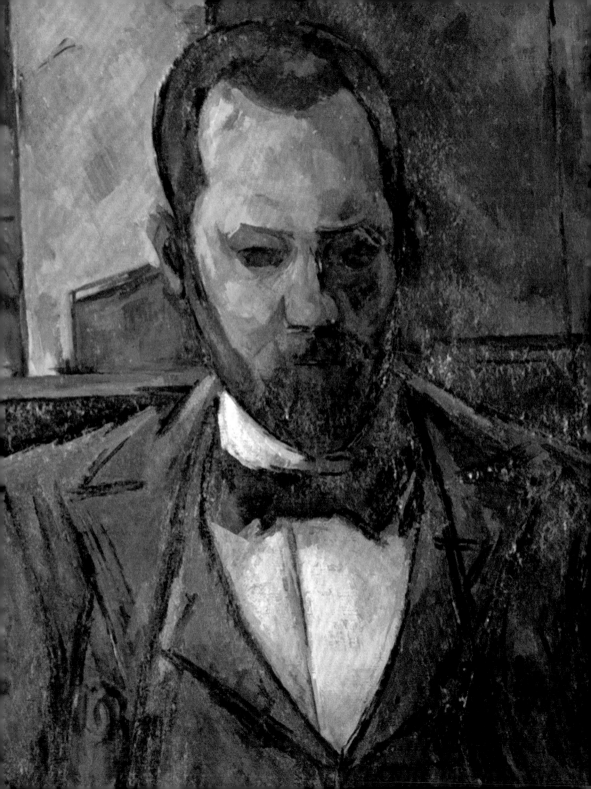

Vollard has been posing every morning
at Cézanne's for what seems like for
ever ... As soon as he moves, Cézanne
complains that he has made him lose the
line of concentration.

Maurice Denis, *Journal*, vol.1, 1905–20

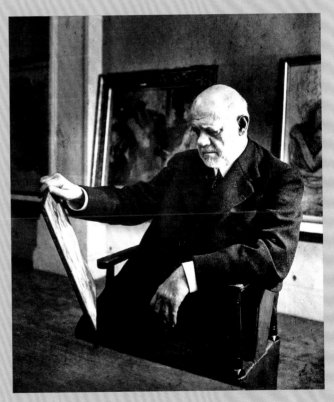

FIG. 24
Ambroise Vollard, photograph,
by Rogi André, 1936

Alfred Hauge

1899
Oil on canvas 718 × 603mm
Norton Museum of Art, West Palm Beach, Florida

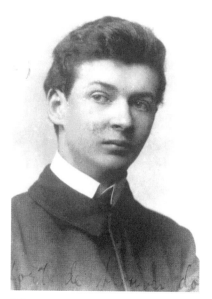

FIG. 25
Alfred Hauge, photograph, c.1899

In the summer of 1899, Cézanne left Paris to work in Marlotte, near Fontainebleau. It was there, at the Hôtel Mallet, that he met a young Norwegian painter, Alfred Hauge. Hauge was well aware of Cézanne's reputation and the two artists would often have dinner together in the hotel garden.

Cézanne in due course offered to paint Hauge's portrait. The work represents a well-dressed, elegant young man. There are similarities with Cézanne's portrait of Vollard in the subdued palette, here in tones of blue and brown, and the pyramidal composition, albeit in a more exaggerated form. Hauge's face, however, is not as fully developed as Vollard's. Blue tones abut orange within larger expanses of cream and ochre; the reddish tones of the background reappear in the blue-black of his hair; and his cravat takes up the same hue, enhanced by the enclosing blues of his jacket.

It is a painting with presence, which makes it all the more surprising that, according to Hauge, Cézanne slashed the work with a knife out of sheer frustration. Signs of damage can still be detected, despite the fact that Cézanne's son, Paul, had the canvas remounted in Paris. Hauge, however, never received his portrait.

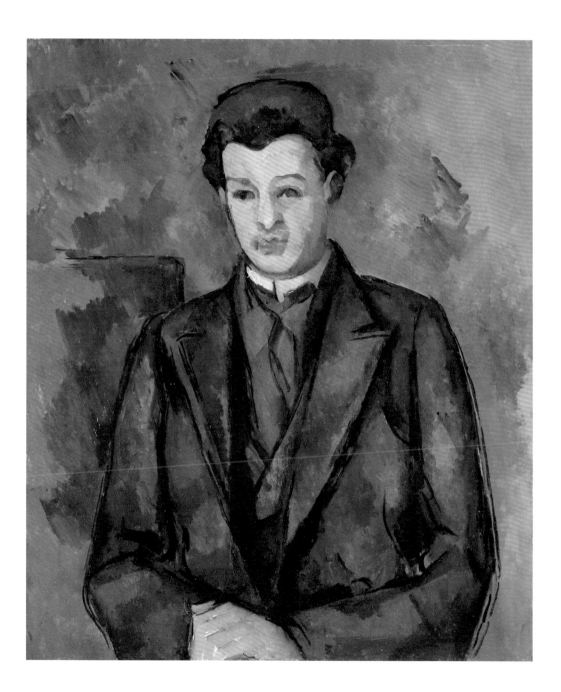

Man with Crossed Arms

c.1899
Oil on canvas 920 × 727mm
Solomon R. Guggenheim Museum, New York

This portrait of an anonymous sitter is one of a pair that the art dealer Ambroise Vollard classified as portraits of peasants. However, the artist's son was known to refer to the sitter as 'the clock-maker'. His long hair, cravat and waistcoat certainly suggest an elegant artisan or bohemian rather than a peasant; Cézanne was alert to, and recorded, such class differences.

There is a melancholic, perhaps angry, sensibility to this portrait with its subdued tonality, reflective of the Aix countryside. It is tempting to link this to Cézanne's distress at the sale in 1899 of the Jas de Bouffan, the family estate that had been his own home. This work was undoubtedly painted at the Jas. There are disturbing elements, not only in the sitter's strangely distorted facial features, where one eye is viewed from above and the other from below, but also in the treatment of his left hand, which is seemingly dislocated from the end of the arm to which it should be attached; his right hand is reduced to a thumb. Cézanne's restless brush-work and intermittent patches of complementary colours form passages of flatness and volume, at once a translucent surface and an illusion of depth.

A palette and other signs of Cezanne's studio are placed in the bottom left corner.

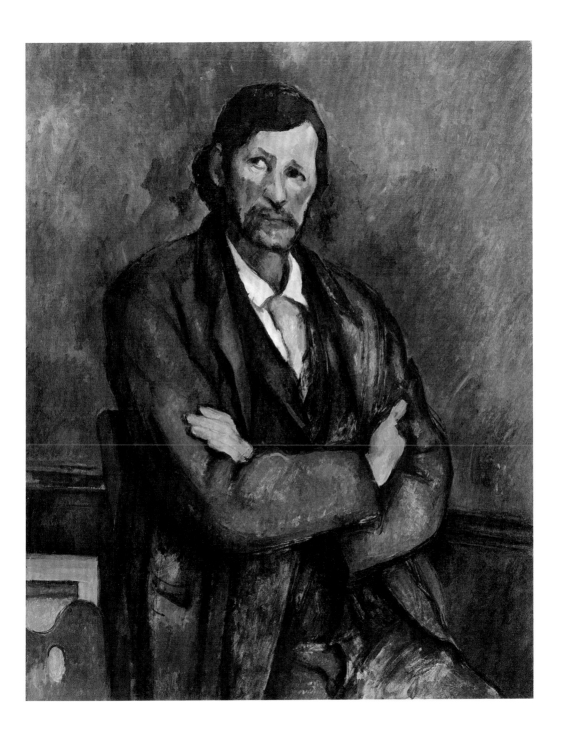

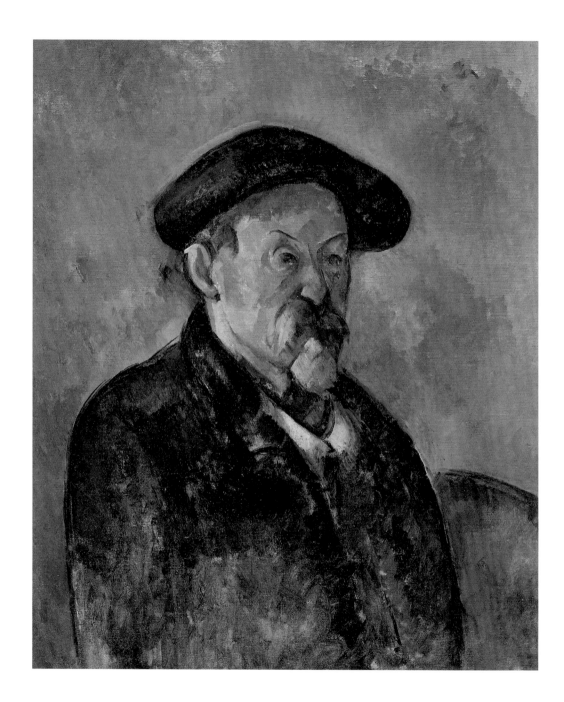

Self-Portrait with Beret

1898–1900
Oil on canvas 641 × 533mm
Museum of Fine Arts, Boston
(see also detail, p.79)

Cézanne's self-portraits, which he returned to throughout
his artistic career, illustrate not only his evolving technique
from palette knife to constructive brush stroke, but repeatedly
play with his own identity: evaluating his rising status
within the social hierarchy, investigating his relationship
with his family, or perhaps his affiliation with the art
history of the past.

In contrast to the unruly, wild character of earlier works
(p.33), or the later, calmer figure in an interior setting (p.40),
or the tight-lipped, glaring expression of the mid-1880s (p.44),
here we see a man in his sixties, suffering with diabetes, in
a somewhat feeble state. Pictured wearing a beret, whose
clean contours and dark monochrome tones are in sharp
contrast to the pale features of the artist's face and the
stark planes of cheekbone and forehead, he looks a shadow
of his former self.

The figure seems to close down, a sort of finale to
Cézanne's singular work in self-portraiture.

I still work with difficulty, but I seem to get along. That is the important thing to me. Sensations form the foundation of my work, and they are imperishable, I think.

**Cézanne's last letter to his son Paul
Aix, 15 October 1906**

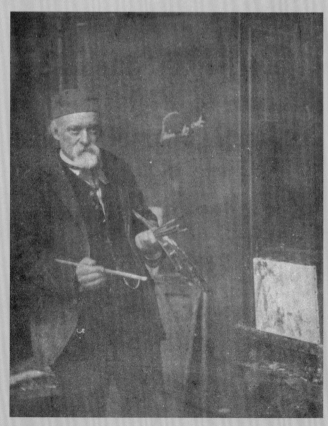

FIG. 26
Paul Cézanne in his Paris studio, working on
The Apotheosis of Delacroix, photograph, 1894

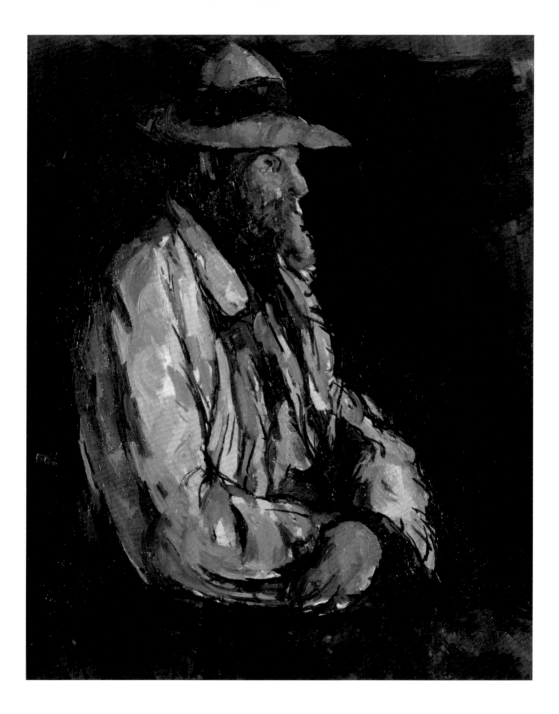

The Gardener Vallier

1906
Oil on canvas 650 × 540mm
Private collection

In 1902 Cézanne moved into his new studio at
Les Lauves, in the hills north of Aix, with its views of
the Provençal countryside. Cézanne rarely painted out
of doors until he moved here, the setting for this portrait
of his gardener, Vallier.

This work, together with its preparatory watercolour,
are thought to be the last portraits in these media that
Cézanne made. The gardener is shown in close-up, at
half-length and in profile. Shaped by schematic drawing,
the work is painted in earthy, natural colours. Cézanne
drew on his late landscapes for Vallier's jacket, his face and
hands. The folds and contours of fabric and skin take on the
appearance of the terrain, while his profile flows from face
to beard to shoulder in an organic progression. The figure
itself glows with light, despite or perhaps because of the
exaggeratedly dark background and the thinned paint
that allows flecks of white canvas to show through.

Joachim Gasquet recounts that Cézanne, when his
model was unavailable, would don his gardener's clothes
and paint himself as Vallier, or perhaps Vallier as himself.
As such this work becomes, in a sense, one of Cézanne's
final self-portraits.

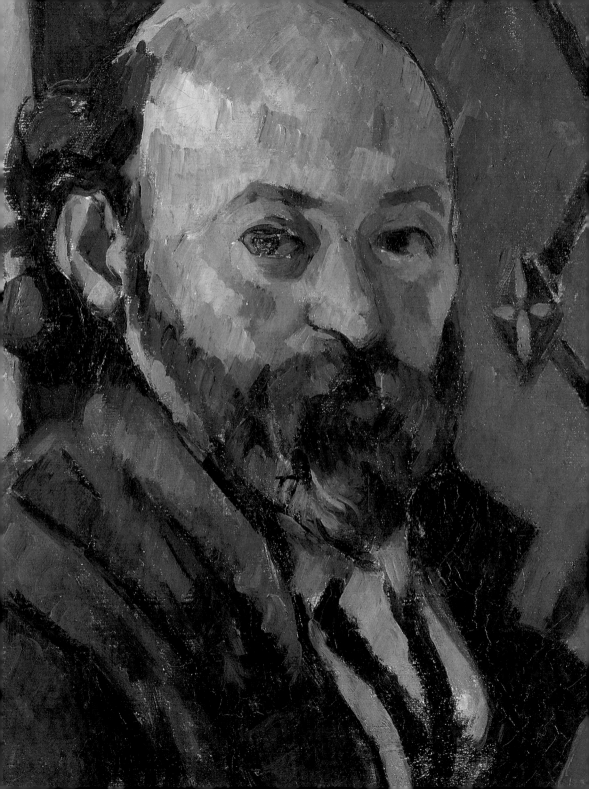

Chronology

1839

19 January: Paul Cézanne is born in Aix-en-Provence, the only son of Louis-Auguste Cézanne (a seller of hats turned banker) and Elisabeth Aubert (a native of Aix).

1844

29 January: Cézanne's parents are married, so legitimising their children.

1850

Cézanne registers at the Catholic Ecole Saint-Joseph, Aix.

1852

He enters the Collège Bourbon, where he meets the writer Emile Zola. Cézanne and Zola, together with Jean-Baptiste Baille, the future astronomer, are known as 'les trois inseparables'.

1857

Cézanne registers at the Ecole Gratuite de Dessin, Aix, where he draws after the live model, as well as from sculptures in the Musée d'Aix.

1859

Cézanne enrols at the law school, Aix. His father buys the Jas de Bouffan, a country property on the outskirts of the town.

FIG. 27
Avenue of Chestnut Trees at Jas de Bouffan, c.1876

1860–1

Cézanne leaves for Paris to learn to paint, with the proviso that he continue his law studies. He enrols at the Académie Suisse, where he meets fellow artists Camille Pissarro and Achille Emperaire. Failing to qualify for the Ecole des Beaux-Arts, he returns to Aix.

1862–4

Cézanne returns to Paris in late 1862 and stays until July 1864. He again studies at the Académie Suisse where he, meets Pierre-Auguste Renoir. He paints his earliest known self-portrait after a photograph.

1865

Cézanne spends the winter of 1865/6 in Aix, working at the Jas de Bouffan, where he paints a mural of his father and a still life (fig.2).

1866

February–August: Cézanne returns to Paris, where he meets Edouard Manet and Claude Monet. April: he submits his 1865 still life and a portrait of the poet Antony Valabrègue to the official Paris Salon, but both are rejected. August: Cézanne is back in Aix, where he paints portraits of his family, including his father (p.26) and his uncle (p.28 and fig.1), all executed using his palette-knife technique.

1867

February: Cézanne is back in Paris, working at the Académie Suisse. Early June: in Aix he paints further portraits, no longer in the palette-knife style but with equal energy, including two portraits of Emperaire.

1868

Cézanne alternates between Paris (January–May) and Aix (May–December), ending the year in Paris at 53, rue Notre-Dame-des-Champs.

1869

He meets the 19-year-old Hortense Fiquet, with whom he forms a personal relationship, a liaison he hides from his father. Cézanne divides his time between the Midi in the south and the Ile-de-France, near Paris. He begins another portrait of Valabrègue (p.30). September–July 1870: he works on two double portraits of Emile Zola and the writer Paul Alexis, painted at Zola's apartment in Paris.

1870

April: Cézanne submits a portrait of Emperaire and a reclining nude to the official Paris Salon; both are rejected. July: France declares war on Prussia. Cézanne, in order to avoid military service, takes refuge in the fishing village of L'Estaque, where Hortense joins him; he paints her portrait and divides his time between studio and the outdoors. He visits Aix regularly and paints his childhood friend Gustave Boyer, plus his own father and his mother.

1871

26 February: Treaty of Versaille brings the Franco-Prussian War to an end. 21–8 May: 'Bloody Week' in Paris; the army suppresses the radical government of the Paris Commune. July: Cézanne and Hortense return to the capital and at the end of the year move into an apartment at 45, rue Jussieu.

1872

4 January: Paul *fils* is born, the couple's only child. Cézanne paints Hortense and their son. Summer: the family stays in Saint-Ouen-l'Aumône, north-west of Paris, where Cézanne paints *en plein air* with Pissarro. Late 1872: the family moves to Auvers-sur-l'Oise, where a number of artists live and work.

FIG. 28

Quai de Jussieu, Paris, 1872

1873

The family spends the year in Auvers.
The artist often paints with Pissarro,
who introduces him to Julien Tanguy,
Cézanne's first picture dealer.

1874

April–May: Back in Paris, Cézanne
submits three paintings to the first
Impressionist exhibition.

1875

Mid-April: the family is by now settled
at 67, rue de l'Ouest, an apartment that
they retain until early 1880. Cézanne
paints a number of self-portraits (p.33)
and portraits of his son (fig.19). End 1875:
through Renoir, Cézanne meets the
collector Victor Chocquet, who becomes
a close friend and early patron.

1876

Summer: Cézanne stays in L'Estaque,
painting seascapes, and in Aix, painting
landscapes. End August: he is back in
Paris, where he begins work on a head
of Chocquet (fig.5).

1877

During the year he paints two portraits
of Chocquet in the collector's rue
de Rivoli apartment (p.34), one of
Hortense at the rue de l'Ouest (p.39),
and at least one self-portrait. April: he
exhibits seventeen works in the third
Impressionist exhibition, including his
head of Chocquet, which is criticised
by the press.

1878

March: Cézanne and Hortense leave
for the Midi; the artist's father learns of
Cézanne's relationship with Hortense
and the existence of their son, and
threatens to cut off his allowance;
Cézanne remains in L'Estaque, while
Hortense and young Paul reside in
Marseille. November–December:
Hortense is in Paris; Cézanne is with
Paul, now aged six, in L'Estaque,
where he makes sketches of his son.

FIG. 29

**House of Père Lacroix,
Auvers-sur-l'Oise**, 1873

1879

April–March 1880: Cézanne is based in Melun, south-east of Paris. Here he paints the son of a family friend, Louis Guillaume, and begins another portrait of Hortense.

1880

April: the family is now living at 32, rue de l'Ouest, Paris, where they remain until 1885. Cézanne paints a self-portrait (p.40) and probably several more canvases of Hortense and son Paul. August: he visits Zola in Médan, west of Paris, and possibly executes a self-portrait there.

1881

May–October: Cézanne and family stay in Pontoise; the artist again paints with Pissarro. October: Cézanne's father has a change of heart and has a studio built for his son at the Jas de Bouffan. Cézanne possibly starts a portrait of Paul *fils* (p.42), employing a looser technique.

1882

March–October: Cézanne is back in Paris. In May his *Portrait de M.L.A...* (p.26) is accepted for the Paris Salon, the first and only time. Summer: Cézanne and family stay with the Chocquets in Hattenville, Normandy, where Cézanne paints landscapes.

1883

30 April: death of Edouard Manet. Cézanne divides his time between Aix and L'Estaque, where he spends May–September with Hortense and Paul *fils*. He possibly makes sketches of Hortense here. Monet and Renoir visit Cézanne at the end of the year.

1884

Cézanne spends most of the year in Aix.

FIG. 30
Gardanne, *c.*1885

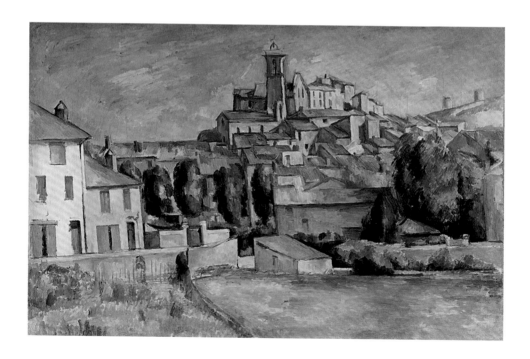

1885

June–July: the family stays with the Renoirs at La Roche Guyon, Ile-de-France; Cézanne then leaves for Aix, Hortense for Paris. End August: Cézanne is working in Gardanne, near Aix. November: the family joins him and they stay here until October 1886. Cézanne paints several self-portraits (p.44) and further portraits of Hortense (p.47).

1886–7

March: Zola's novel *L'Oeuvre* is published, the story of a brilliant but failed artist, who resembles Cézanne. 28 April: Cézanne and Hortense are married in Aix. 23 October: Cézanne's father dies, leaving his son a considerable inheritance. The artist now lives at the Jas de Bouffan with his mother; Hortense and Paul *fils* live in Aix. He paints Hortense at the Jas (p.48) and possibly Paul *fils*.

1888

February: Cézanne and Hortense move to 15, quai d'Anjou, Paris, an address they keep until 1890. Cézanne begins a series of canvases of model Michelangelo de Rosa (p.51) and paints Hortense wearing a red dress (p.52). He also rents a studio on the rue du Val-de-Grâce, where he works on a series of Harlequin studies and a large composition titled *Mardi Gras* (fig.8), for which Paul *fils* and Louis Guillaume are the models. July–November: Cézanne is in Chantilly, outside Paris, where he paints landscapes.

FIG. 31
Le Moulin brûlé, Maisons-Alfort, *c*.1894

1889

June: the Cézannes stay with the Chocquets once more in Hattenville; the artist paints his friend Victor, seated in his garden. July–November: Cézanne is back at the Jas de Bouffan. 13 December: Hortense's father dies.

1890

May–November: the Cézannes travel to Emagny to settle Claude Fiquet's estate and then on to Switzerland, a fraught family vacation. Hortense returns to Paris; Cézanne to the Jas de Bouffan, where he starts to suffer from diabetes.

1891

February: Cézanne moves Hortense and Paul *fils* to 9, rue de la Monnaie, Aix. He continues to live at the Jas, where he paints Hortense's portrait. December: the Belgian painter Eugène Boch buys Cézanne's large portrait of Emperaire for 800 francs.

1891–6

Aix: Cézanne works on a series of portraits and studies of farmworkers at the Jas de Bouffan, many of which form the basis for his Card Player compositions. He also works on portraits of a young *Aixois* girl.

FIG. 32
Lac d'Annecy, 1896

1897–9

Cézanne continues his portrait series of *Aixois* workmen at the Jas (p.67 and fig.11). June–September: he rents a cottage in Le Tholonet, just outside Aix, to work *sur le motif*. Hortense joins him in Aix. 25 October: Cézanne's mother dies.

1898

January: Cézanne is back in Paris, where he rents a studio at 15, rue Hégésippe-Moreau. May: the couple moves to 31, rue Ballu, their home for the next six years. Here the artist probably paints his last self-portrait, wearing a beret (p.77). May–June: Vollard exhibits sixty paintings by Cézanne, five of which are portraits.

1899

The collector Auguste Pellerin buys the first of thirty-four portraits by the artist. Cézanne paints Vollard's portrait (p.68) at his Paris studio. July–August: Cézanne is in Marlotte, near Fontainebleau, where he meets a young Norwegian artist, Alfred Hauge, and paints his portrait (p.72). Back in Aix, he works on an elegant portrait of an artisan, possibly the clock-maker (p.74). November: the Jas de Bouffan is sold. Cézanne takes an apartment at 23, rue Boulegan in Aix, where he paints a young Italian girl the following year.

1892–3

Cézanne travels in and around Aix, Paris and Fontainebleau. October 1893: a self-portrait is exhibited at the Paris gallery Le Barc de Boutteville.

1894

Cézanne is in Alfort and Melun, outside Paris, painting landscapes along the Marne. November: he visits Monet in Giverny, where he works on a self-portrait, which he abandons. December: *Madame Cézanne in a Striped Dress* is reproduced in *Le Coeur* (the first time a portrait of Cézanne's appears in print).

1895

April–June: the artist works on a portrait of the writer and critic Gustave Geffroy (p.54). End June–May 1896:

Cézanne is back at the Jas de Bouffan, painting further portraits of local *Aixois* women, servants and house-keepers (pp.59, 60). He climbs Mont Sainte-Victoire. November: Ambroise Vollard becomes his dealer and holds Cézanne's first solo show in his rue Laffitte gallery, Paris. At least fifteen portraits can be identified, most of them bought by fellow artists.

1896

June–August: the family spends the summer in Vichy and then Talloires, by Lac d'Annecy. Cézanne makes sketches of the gardener's young son at the Hôtel de l'Abbaye and paints his portrait (p.62). Winter (or early spring 1897): Cézanne makes portraits of the poet Joachim Gasquet and his father at the Jas de Bouffan.

1900

Cézanne's reputation begins to grow. Maurice Denis, who called the artist the 'Master of Aix', paints his *Homage to Cézanne*. November–December: the Bruno and Paul Cassirer Gallery, Berlin, presents the first exhibition of Cézanne's paintings in Germany. Four portraits are shown.

1901

May–June: a self-portrait belonging to Dutch collector Cornelis Hoogendijk is exhibited in the first international exhibition in The Hague. November: Cézanne buys a plot of land at Les Lauves, near Aix, and starts to build a studio there. November–May 1902: Hortense is in Aix, and now visits for a few months each year.

1902

Art dealers Josse and Gaston Bernheim-Jeune buy a self-portrait from Cézanne, who begins a series of portraits of his gardener (p.81). 29 September: death of Zola.

1903

13 November: death of Pissarro.

1904

October–November: a room is dedicated to Cézanne's work at the Salon d'Automne, including ten portraits. He works on a canvas of *The Bathers*, some landscapes and watercolours. December: the American expatriates Leo and Gertrude Stein purchase a portrait of Madame Cézanne from Vollard for 8,000 francs.

1905

January–February: Cézanne's paintings appear for the first time in London at the Grafton Galleries.

1906

January: Denis travels to Provence and visits Cézanne at his studio. 15 October: Cézanne collapses while painting in the rain. 23 October: Cézanne dies at his rue Boulegon apartment and is buried at the Cimetière Saint-Pierre, Aix.

1907

Cézanne retrospective is held at the Salon d'Automne, Paris, a seminal moment for future Cubists, such as Picasso, and a watershed event in art history.

FIG. 33
Mont Sainte-Victoire, View from Les Lauves, 1902–6

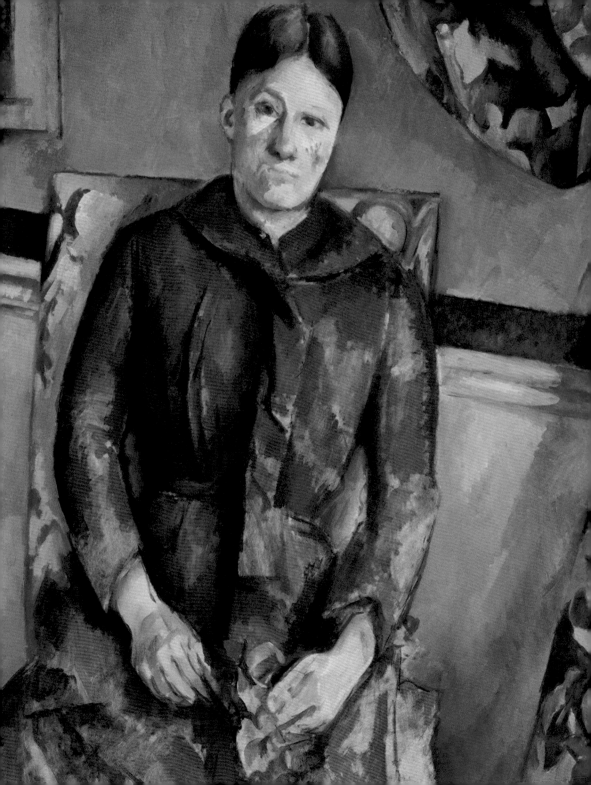

Picture Credits

The National Portrait Gallery would like to thank the copyright holders for granting permission to reproduce works illustrated in this book. Every effort has been made to contact the holders of copyright material, and any omissions will be corrected in future editions if the publisher is notified in writing. Dimensions of works are given height × width (mm), where available.

All works are by Paul Cézanne unless otherwise noted.

HIGHLIGHTS

These works are taken from the exhibition *Cézanne Portraits*. They appear in all exhibition venues unless indicated otherwise, using the following abbreviations:

P Paris, Musée d'Orsay
L London, National Portrait Gallery
W Washington, D.C., National Gallery of Art

PAGE 26
The Artist's Father, Reading L'Événement, 1866
Oil on canvas, 2000 × 1200mm
National Gallery of Art, Washington, D.C.;
Collection of Mr and Mrs Paul Mellon,
(1970.5.1)

PAGE 28
Uncle Dominique as a Lawyer, 1866–7
(P ONLY)
Oil on canvas, 620 × 520mm
Musée d'Orsay, Paris
Photograph © RMN-Grand Palais
(Musée d'Orsay)/Hervé Lewandowski

PAGE 30
Antony Valabrègue, 1869–70
Oil on canvas, 600 × 502mm
J. Paul Getty Museum, Los Angeles
Digital image courtesy of the Getty's
Open Content Program

PAGE 33
Self-Portrait, c.1875
Oil on canvas, 640 × 530mm
Musée d'Orsay, Paris; Gift of Jacques
Laroche, 1947
Photograph © RMN-Grand Palais
(Musée d'Orsay)/Hervé Lewandowski

PAGE 34
Victor Chocquet, 1877
Oil on canvas, 460 × 380mm
Columbus Museum of Art, Ohio; Museum
Purchase, Howald Fund (1950.024)

PAGE 39
Madame Cézanne in a Red Armchair, c.1877
Oil on canvas, 725 × 560mm
Museum of Fine Arts, Boston;
Bequest of Robert Treat Paine, II
Photograph © 2017 Museum of
Fine Arts, Boston

PAGE 40
Self-Portrait, 1880–1
Oil on canvas, 336 × 260mm
National Gallery, London; Bought,
Courtauld Fund, 1925
© National Gallery, London

PAGE 42
The Artist's Son, 1881–2
Oil on canvas, 350 × 380mm
Musée de l'Orangerie, Paris
Photograph © RMN-Grand Palais
(Musée de l'Orangerie)/Franck Raux

PAGE 44
Self-Portrait with Bowler Hat, 1885–6
Oil on canvas, 445 × 355mm
Ny Carlsberg Glyptotek, Copenhagen
Photograph: Ole Haupt

PAGE 47
Madame Cézanne, 1885–6
Oil on canvas, 460 × 380mm
Philadelphia Museum of Art; Samuel S.
White, III, and Vera White Collection
(1967-30-17)

PAGE 48
Madame Cézanne in Blue, 1886–7
Oil on canvas, 735 × 610mm
Museum of Fine Arts, Houston;
Robert Lee Blaffer Memorial Collection,
Gift of Sarah Campbell Blaffer

PAGE 51
Boy in a Red Waistcoat, 1888–90
Oil on canvas, 920 × 730mm
National Gallery of Art, Washington, D.C.;
Collection of Mr and Mrs Paul Mellon, in
Honour of the 50th Anniversary of the
National Gallery of Art (1995.47.5)

PAGE 52
Madame Cézanne in a Red Dress, 1888–90
Oil on canvas, 1160 × 890mm
Metropolitan Museum of Art, New York;
Mr and Mrs Henry Ittleson, Jr,
Purchase Fund, 1962 (acc.no. 62.45)

PAGE 54
Gustave Geffroy, 1895–6
Oil on canvas, 1160 × 890mm
Musée d'Orsay, Paris; Gift of the
Pellerin Family, 1969
Photograph © RMN-Grand Palais
(Musée d'Orsay)/Hervé Lewandowski

PAGE 59
Woman with a Cafetière, c.1895
Oil on canvas, 1300 × 970mm
Musée d'Orsay, Paris; Gift of Mr and Mrs
Jean-Victor Pellerin, 1956
Photograph © RMN-Grand Palais
(Musée d'Orsay)/Hervé Lewandowski

PAGE 60
Old Woman with a Rosary, 1895–6
Oil on canvas, 806 × 655mm
National Gallery, London; Bought, 1953
© National Gallery, London

PAGE 62
Child in a Straw Hat, 1896
Oil on canvas, 689 × 581mm
Los Angeles County Museum of Art;
Mr and Mrs George Gard De Sylva
Collection (M.48.4)

PAGE 65
Man with a Pipe, 1891–6 (L, W ONLY)
Oil on canvas, 730 × 600mm
Samuel Courtauld Trust,
Courtauld Gallery, London

PAGE 67
Man in a Blue Smock, c.1897
Oil on canvas, 815 × 648mm
Kimbell Art Museum, Fort Worth, Texas;
Acquired in 1980 and dedicated to the
memory of Richard F. Brown

PAGE 68
Ambroise Vollard, 1899
Oil on canvas, 1010 × 810mm
Musée des Beaux-Arts de la Ville de Paris,
Petit Palais, Paris
Photograph © RMN-Grand Palais/
Agence Bulloz

PAGE 72
Alfred Hauge, 1899
Oil on canvas, 718 × 603mm
Norton Museum of Art, West Palm Beach,
Florida; Gift of R.H. Norton (48.5)

PAGE 74
Man with Crossed Arms, c.1899
Oil on canvas, 920 × 727mm
Solomon R. Guggenheim Museum,
New York (54.1387)

PAGE 77
Self-Portrait with Beret, 1898–1900
Oil on canvas, 641 × 533mm
Museum of Fine Arts, Boston; Charles H.
Bayley Picture and Painting Fund and
Partial Gift of Elizabeth Paine Metcalf
(1972.950)
Photograph © 2017 Museum of
Fine Arts, Boston

PAGE 81
The Gardener Vallier, 1906 (W ONLY)
Oil on canvas, 650 × 540mm
Private collection
Photograph © akg-images

ADDITIONAL PICTURE CREDITS

FIG. 1
Uncle Dominique as a Monk, 1866–7
Oil on canvas, 651 × 546mm
Metropolitan Museum of Art, New York
(1993.400.1); Gift of Walter H. and
Leonore Annenberg, 1993; Bequest of
Walter H. Annenberg, 2002

FIG. 2
*Still Life with Sugar Bowl, Pears and
Blue Cup*, 1865–6
Oil on canvas, 300 × 410mm
Musée Granet, Aix-en-Provence
Photograph © akg-images

FIG. 3
Armand Guillaumin, *View of the Seine,
Paris*, 1871
Oil on canvas, 1264 × 1813mm
Museum of Fine Arts, Houston; Gift of
Audrey Jones Beck, 71.5

FIG. 4
Camille Pissarro, *Portrait of Paul Cézanne*,
1874
Oil on canvas, 730 × 597mm
National Gallery, London; Courtesy of
Laurence Graff OBE

FIG. 5
Portrait of Victor Chocquet, 1876–7
Oil on canvas, 460 × 360mm
Private collection
Photograph © Bridgeman Images

FIG. 6
Château at Medan, c.1880
Oil on canvas, 591 × 724mm
Burrell Collection, Glasgow
© Culture and Sport Glasgow (Museums)/
Bridgeman Images

FIG. 7
Madame Cézanne with a Fan, c.1879,
reworked 1886–8
Oil on canvas, 925 × 730mm
Foundation E.G. Bührle Collection, Zurich

FIG. 8
Mardi Gras, c.1888
Oil on canvas, 1020 × 810mm
Pushkin State Museum of Fine Arts, Moscow
© 2017. Photo Scala, Florence

FIG. 9
Edgar Degas, *Portrait of Edmond Duranty*,
1879
Gouache with pastel enlivenment on linen,
1280 × 1286mm
Burrell Collection, Glasgow
Photograph © akg-images

FIG. 10
Edouard Manet, *Portrait of Emile Zola*, 1868
Oil on canvas, 1460 × 1140mm
Musée d'Orsay, Paris
Photograph © Laurent Lecat/akg-images

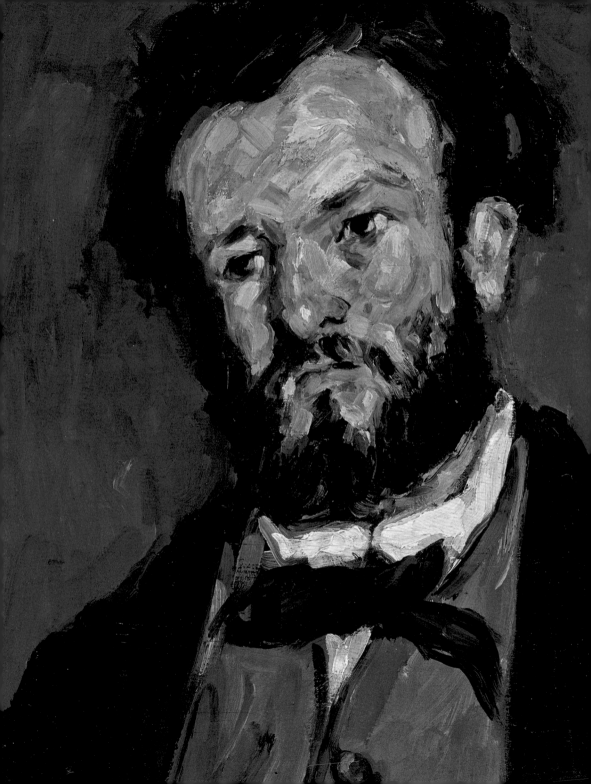

Index

Page numbers in italics refer to illustrations

Musée d'Orsay, Paris
13 June to 24 September 2017

National Portrait Gallery, London
26 October 2017 to 11 February 2018

National Gallery of Art, Washington, D.C.
25 March to 1 July 2018

Published in Great Britain by
National Portrait Gallery Publications,
St Martin's Place, London WC2H 0HE

Every purchase supports the National Portrait Gallery, London.
For a complete catalogue of current publications, please
write to the National Portrait Gallery at the address above,
or visit our website at www.npg.org/publications

Texts in the plates section and the chronology are based on
catalogue entries and the chronology (respectively) in *Cézanne
Portraits* by John Elderfield with Mary Morton and Xavier Rey,
and Jayne S. Warman, published in Great Britain in 2017 by
National Portrait Gallery Publications.

ISBN 978 1 85514 716 4

A catalogue record for this book is
available from the British Library.

10 9 8 7 6 5 4 3 2 1

Printed and bound in Italy

MANAGING EDITOR Christopher Tinker
PROJECT EDITOR Denny Hemming
PICTURE RESEARCH Mark Lynch
PRODUCTION MANAGER Ruth Müller-Wirth
DESIGN Philip Lewis

FRONTISPIECE *Madame Cézanne in Blue*, 1886–7 (p.48, detail)
PAGE 4 *Man with Crossed Arms*, c.1899 (p.74, detail)
PAGE 94 *Antony Valabrègue*, 1869–70 (p.30, detail)

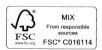